Collins · Learn to Draw

People

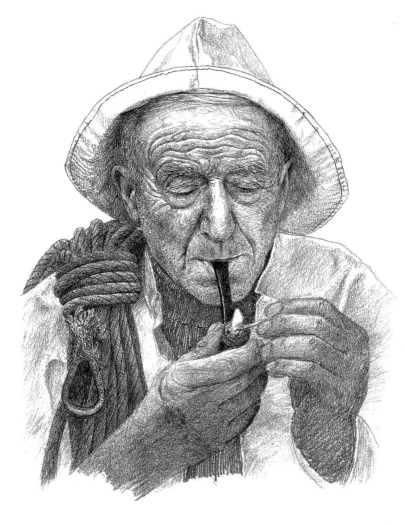

Philip Patenall

First published in 1993 by
HarperCollins Publishers

Reprinted in 2006 by
Collins, an imprint of
HarperCollins Publishers
77–85 Fulham Palace Road
Hammersmith, London W6 8JB

The Collins website address is:
www.collins.co.uk

Collins is a registered trademark of HarperCollins Publishers Limited.

07 09 10 08 06
2 4 6 7 5 3 1

© Diagram Visual Information 1993

A catalogue record for this book is available from the British Library.

Editor: John Morton
Art Director: Darren Bennett
Contributing artists: Laura Andrew, Peter Campbell, Arthur Lockwood, John Meek, Bruce Robertson, Graham Rosewarne, Christine Vincent

ISBN–13 978 0 00 721691 8
ISBN–10 0 00 721691 2

Colour reproduction by Colourscan, Singapore
Printed and bound by Printing Express Ltd, Hong Kong

CONTENTS

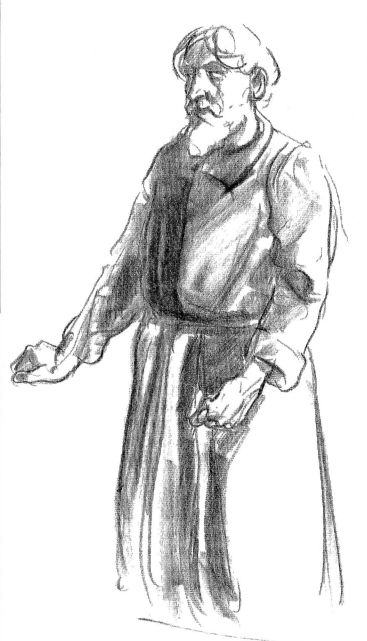

Tools and Equipment

Pencils

The pencil is an extremely useful drawing tool, with a versatility that embraces both rough, quick sketches and finely worked portraits.

The softest graphite, or 'lead', pencil is the 9B grade that produces rough-edged, thick black lines. At the other end of the hardness scale is the 9H pencil, which makes fine, faint lines.

HB pencil is the medium grade. Soft pencils allow great tonal variation, a useful quality for conveying hair or skin textures. The softer the grade of the graphite pencil, the more readily it is erased. It can be smudged to create soft, blurred tones.

As well as clutch, propelling and specialized professional pencils, there is a wide range of coloured pencils, which are particularly effective for giving soft flesh tones.

Experiment with as many different pencils as possible to discover what effects they produce and which suits your style best.

The detailed picture of the shepherd and his dogs below was drawn on smooth paper with a 2B pencil

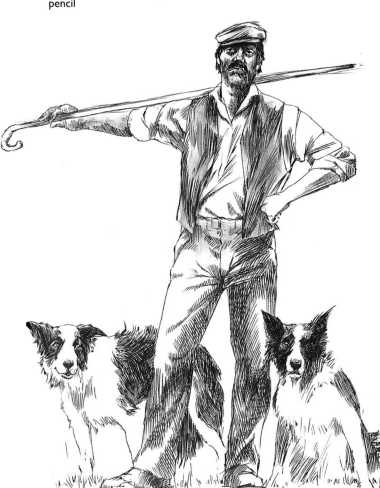

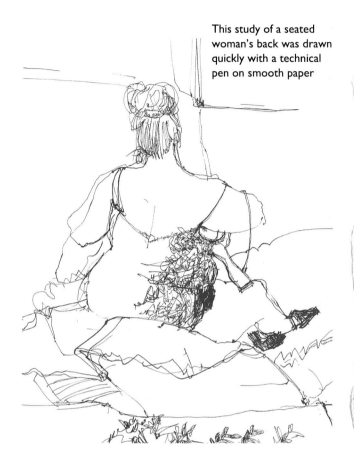

This study of a seated woman's back was drawn quickly with a technical pen on smooth paper

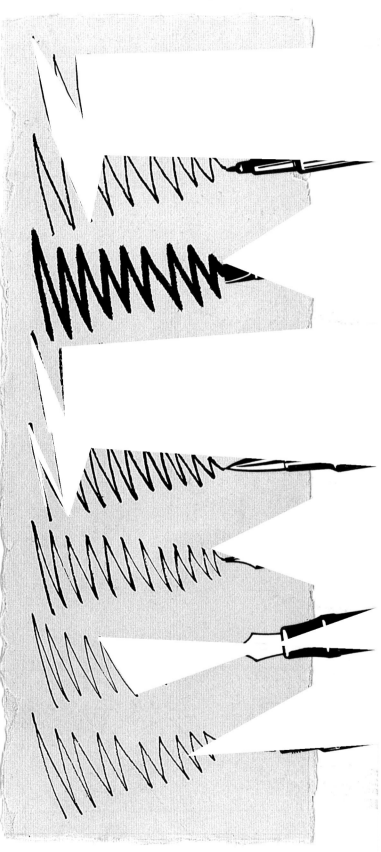

Pens

There are many types of pen, which exhibit a variety of qualities.

More or less pressure applied on **dip** or **fountain pen** nibs increases or reduces stroke thicknesses, allowing greater flexibility. Nibs are made in different widths and there are a variety of coloured inks for dip pens.

Felt-tip pens come in a wide range of breadths and colours. They make bold, bright lines. **Technical pens**, with various nib widths, are used for detailed work but need care in use. **Ball-point pens** may be used for sketching but overworked lines tend to become blotchy.

Don't damage nibs by using too much pressure. Always replace the caps and wash out ink pens when you've finished – dried ink is hard to remove and clogs the pen, which may affect the quality of the lines it makes.

Pastels, crayons and chalk

Pastels and crayons lack the precision of pencils or pens but the varied textures, lines and tones they make can create lively, spontaneous drawings.

Both wax crayons and pastels are manufactured in a wide spectrum of colours, from subtle shades to dazzling rainbow hues. Soft, **oil-based pastels** can be blended with your finger to create vivid effects that almost resemble those produced with oil paints. Pastels are best used on rough papers, which can help to give your work greater textural variety. **Wax crayon** work is best blended using overlapping cross-hatched lines – don't overdo it, though, or you'll muddy the colours. **Coloured chalks** may be used to create delicate portraits of great subtlety.

Crayons and pastels are hard to erase, so you may want to make preparatory sketches in pencil before you add colour.

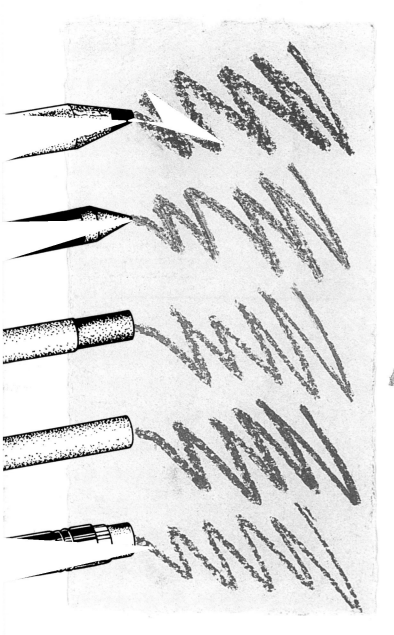

The thick, fluid strokes that depict the seated woman above were made with charcoal on textured paper

I used bold, lively conté-crayon lines on cartridge paper to depict the two figures above

Charcoal and conté crayon

Charcoal is available in stick or pencil form. Harder than crayons or pastels, you can use its point to make fine or thick strokes. The side of a stick can be used to cover large areas or to create bolder strokes. Although fragile – charcoal breaks easily and is prone to smudging – you'll soon learn to exploit its qualities to make either delicate lines or dense, heavy black ones.

Use your fingertip to blend and soften strokes. A kneadable putty rubber can also be used for blending, and it will erase charcoal marks or create highlights in an area of shadow. Use chalk, pastel or crayon to add highlights, too.

Conté crayons are made in stick form. They are less crumbly than charcoal but, because they have a slightly greasy texture, they are harder to smudge or erase. They are supplied in sepia, terracotta, white and black.

Protect pastel, conté crayon or charcoal drawings by partially covering them with a clean piece of paper. Rest your hand on the paper while you work.

Brushes

Brushes, of course, are used to add colour to large or small areas. But they can also be used to create lively and dynamic lines of delicate subtlety or startling power. Springy brushes are far more expressive than 'dead' ones, so be sure to clean them after use and store them upright.

Brush tips come in various sizes and shapes.
Long-tipped, pointed brushes produce thick or thin strokes.
Short-tipped, pointed brushes are easier to control and are best used for adding fine detail.
Flat brushes, short or long, are the best type for covering large areas.

The best brush fibre is sable. It is expensive but long-lasting and it gives beautiful results. Cheaper squirrel and synthetic fibres can be used to produce work of good quality, too.

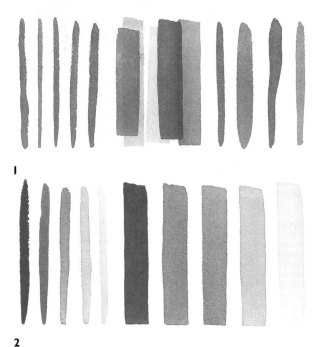

1

2

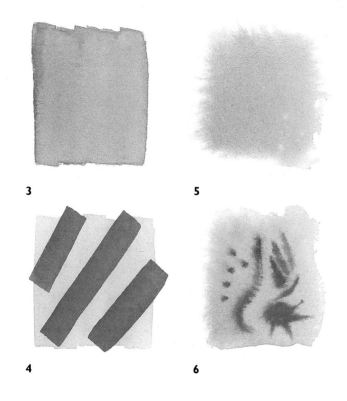

3

5

4

6

3 If you want to paint an even layer of strong watercolour, start with a light wash, gradually adding darker washes to the wet wash below

4 If you need to paint a different tone or colour over another and to leave a distinct edge between them, prevent blending by letting the first layer dry before adding the next

5 Watercolour painted onto a surface dampened with a little water will spread and be absorbed by the paper, creating an area of colour with soft, delicate edges

6 Ink or concentrated watercolour brushed onto dampened paper can result in interesting and unusual effects, such as swirls and blotches

Wet media

Oil paints are costly, slow-drying and require skill for effective use. Water-based paints or inks are cheaper and far better for amateurs.

Watercolour can be diluted with water to give transparent tones and gentle effects (especially on absorbent paper) or less water can be used to produce strong, vivid colours. Pencil marks that show through transparent washes can add interest and help to outline forms.

1 Different brushes make different strokes on the same paper: these were made with (*from left to right*) a small, pointed brush; a flat brush; a large, pointed brush

2 Watercolour tone is progressively reduced in strength by adding more water, as you can see from these strokes produced with different amounts of water

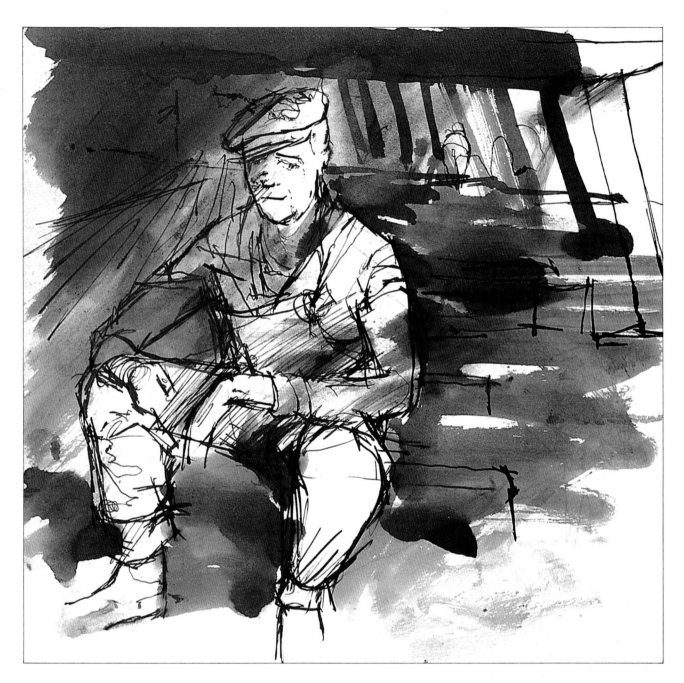

Gouache is a form of watercolour that gives opaque, bold colour and masks pencil sketching. **Acrylic paints** can be diluted with water to resemble watercolour. If used undiluted, they will look like oils.

Use a heavy paper that won't buckle when you work with wet media. You will need a palette on which to mix colours and a jar or jars of water.

I used a dip pen and ink to outline and then add a little detail to the figure above. A watercolour wash was used for the background tones

Oil-based crayons or pastels repel water-based paints, and the two different media can be combined to produce fascinating results that will add an unusual touch to a picture.

Newsprint is
inexpensive making
it good for sketching
and practising

Tracing paper is
semi-transparent so it
lets you trace other
images quickly

Stationery paper is
usually available in
one standard size. It
works well with pen

Cartridge paper, usually
textured and of a high
quality, is one of the most
versatile surfaces

Surfaces to draw on

Your choice of paper or board is vital and can radically alter the look of the final artwork. There are a few 'dos' and 'don'ts' when selecting a surface, but there's room to experiment with different combinations of media to see which you prefer.

There are three ways in which paper is made. **Handmade paper** is expensive and no two sheets are identical. Unlike some mass-produced papers, it is of a high quality and is long-lasting. A formal portrait for framing will seem more impressive if drawn or painted on an attractive-looking paper.

Like handmade paper, **mould paper** is made in single sheets but with less variability. It has a right and a wrong side.

Machine-made paper is manufactured in rolls which are then cut into identical sheets.

Finishing processes affect surfaces – hot-pressed paper has a smooth surface but patterns in the moulds used to make wove or laid paper impart a subtle overall surface texture.

Some papers and boards are unsuitable for certain media – pastel, crayon or chalk, for example, do not work well on smooth surfaces as the particles do not cling to them so well. On the other hand, if you use a fine technical pen on a heavily textured paper you'll find the fine lines are broken up by the rough surface – a smooth art card or board is best for this sort of work. Conté crayon or charcoal on pastel-tinted paper can be used to create striking drawings.

Watercolour needs thick, absorbent paper to hold the paint yet prevent it seeping through to the next sheet in a pad; thickness helps to prevent buckling when a lot of water is used.

The strokes on the swatches on these pages were made with (*from left to right*) a 3B pencil, a 2B pencil, a felt-tip pen, a conté crayon and a charcoal stick. You can see how the appearance of each medium changes on different surfaces.

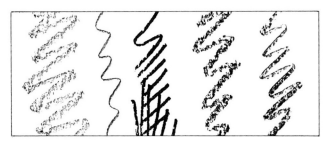

Ingres paper is often used
with charcoal or pastels.
It is available in white and
pale shades

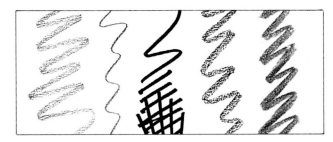

Watercolour paper is
thick and absorbent,
so it works well with
wet media

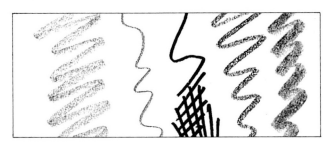

Bristol board is
stiff, with a smooth
surface, and is best
for pen drawings

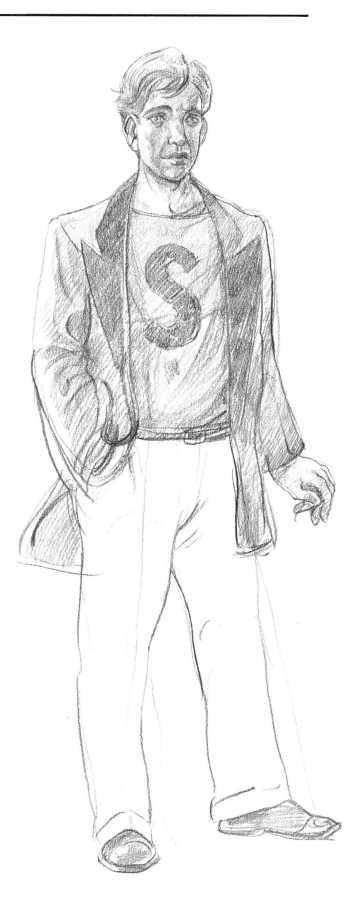

Layout paper is a semi-
opaque, lightweight paper
that works best with
pencils and pens

I used 4B pencil on
cartridge paper to give
this sketch (right) a
textured appearance

Choosing the Right Medium

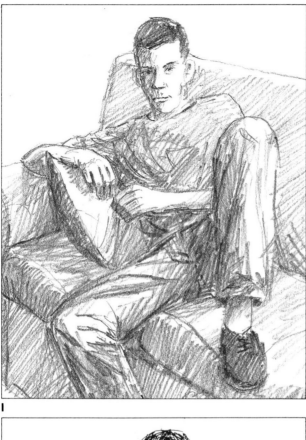

1

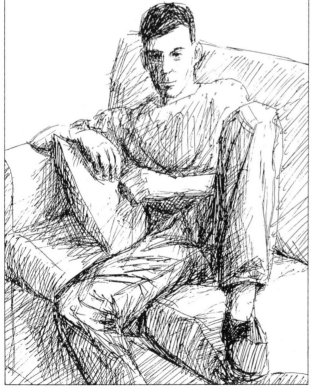

2

Choosing the right medium in which to work is very important, especially if there is a particular effect you want to create or a particular mood you wish to convey. Different combinations of tools will result in work of varying styles and emphases. You can see this by looking at the drawings on these pages. They are all of the same man in the same pose, yet they are all very different.

You can see that ball-point pen on Bristol board (**2**) gives very sharp, clean lines. Compare this with either the soft-pencil portrait (**1**) or the charcoal one (**5**). Though the lines of neither are as sharp, tone and contrast (see pp. 20–21) have been used to great effect in both. They also seem to express a much softer, more melancholy mood.

Familiarize yourself with combinations of different media and different surfaces. You'll soon find you can quickly call to mind the ideal combination to express a particular feeling or effect.

The drawings on these pages were made with the following combinations of media and surfaces:
1 Soft pencil on cartridge paper
2 Ball-point pen on Bristol board
3 Dip pen and ink wash on thick cartridge paper
4 Hard pencil on tracing paper
5 Charcoal on textured paper
6 Watercolour on watercolour paper

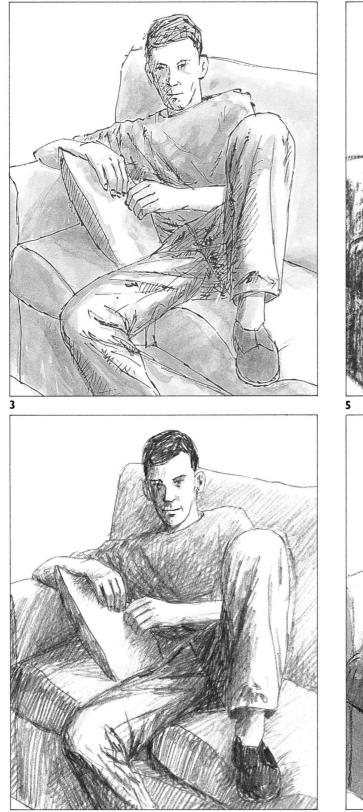

3

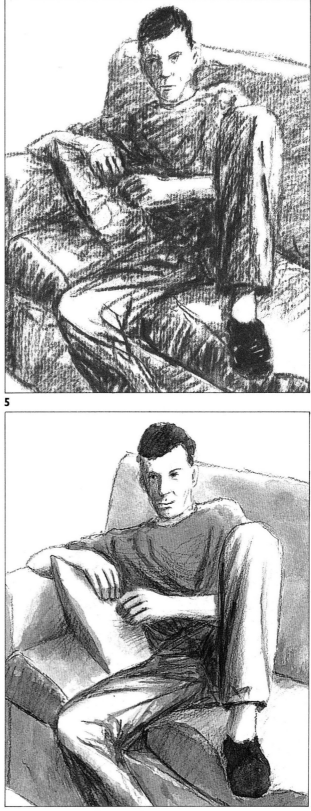

5

4

6

Measuring in Drawing

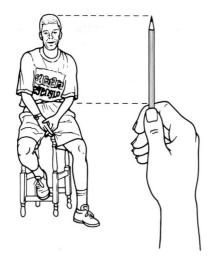

Beginners are often disappointed that sketches of people don't 'look right'. This may be because the relative proportions of the face or body are wrong. Luckily, it's easy to get them right.

Pencil measuring
Use a pencil for measuring. If, for example, you want to check the gap between the subject's waist and the top of the head, hold a pencil upright in your hand, thumb uppermost (*left*). Then, closing one eye to prevent double vision, line up the pencil point with the head and align the top of your thumb with the waist. Keeping your thumb in place, move the pencil to your paper to transfer the measurement. Use the same method to check widths, and incline your pencil to measure limbs that are at an angle.

I began by drawing the central vertical and horizontal axes. I then added some shorter lines at right angles (*below left*), using pencil measuring

Once my grid was detailed enough, I sketched in the main shapes (*below*), checking the proportions with my pencil as I did so

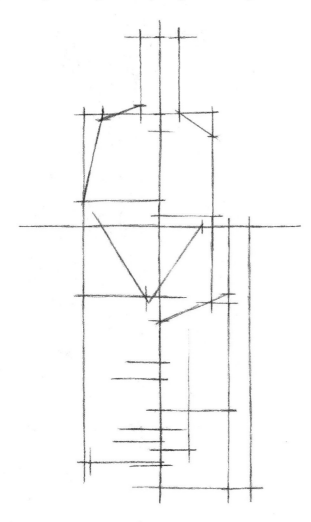

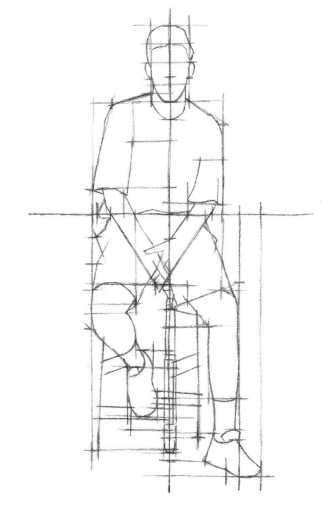

Verticals and horizontals

To achieve the correct proportions in a drawing, it helps to position its parts on a simple grid. First find the main axis of your subject – a horizontal one for a sleeping figure or a vertical axis for a standing or sitting one – and mark it as a faint line on your paper. Add shorter lines at right angles to the main axis to complete the grid; you may need diagonals for some parts. These lines will form reference points against which you'll be measuring constantly to place elements of the sketch accurately. Identify lines relating to distinctive, easily recognized elements, such as a belt or the line formed by the centre of the nose. Use pencil measuring to mark in features and to check that the proportions are correct.

Next, I added the main details, such as the facial features (*below*)

In the finished drawing (*right*), I gave depth and shape to the image by adding finer detail and tones. I constantly checked the proportions, at all stages, by using pencil measuring

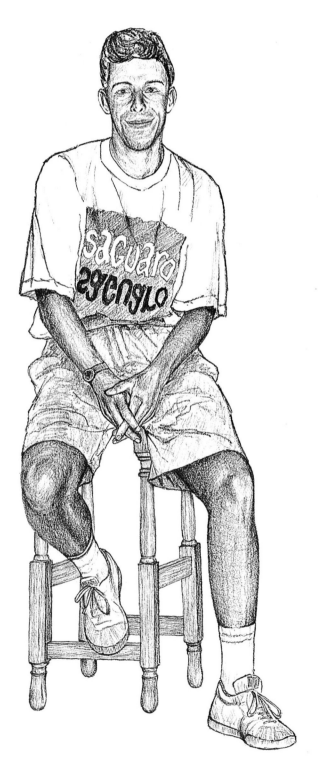

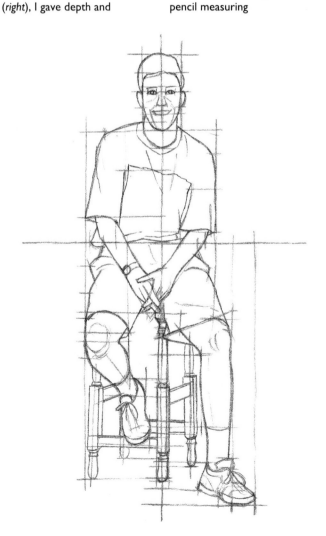

Proportion and Shapes

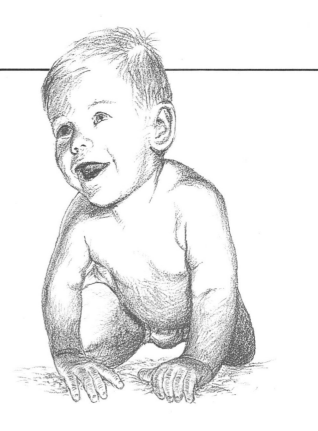

Observation over the years has led artists to develop an idealized human body, each part of which has a set size proportionate to the rest of the body. A knowledge of this ideal form may help you to draw people whose bodies are hidden by clothes. But don't be a slave to such ideals – few of us look like gods or goddesses and no two people are identical; some have long or short legs, others are fat or thin. The figures on these pages show how anatomical proportions alter with age. Observing how reality deviates from such ideals can be an aid to realistic figure drawing.

At different stages of maturity, the height of a person in head-lengths (*below* and *opposite*) is as follows:

1 3–4-year-old: five
2 7–8-year-old: six
3 10–12-year-old: seven
4 Adolescent: seven and a half
5 and 6 Adult: eight

These figures (*below*) show how limbs lengthen in relation to the head as people mature. The legs of a 3–4-year-old (1) are about 2 head-lengths long compared with a ratio of 4:1 in a mature figure (5 and 6)

This simple B-pencil drawing of a baby (*right*) shows how large its head is in relation to its body

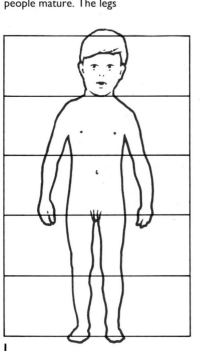

1

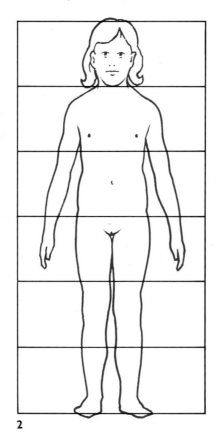

2

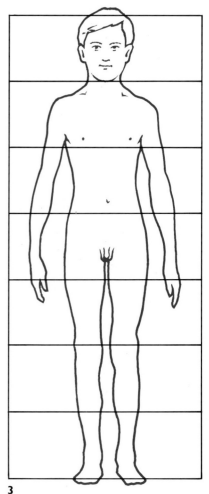

3

Children

When compared with its body, a child's head is far larger than an adult's. As a child grows up the head gets smaller in relation to the body. Girls reach puberty first, but in both sexes it heralds more muscularity, and losses and gains of fat in different parts of the body.

Adults

By adulthood, men are taller than women but both are about eight head-lengths tall. From this ideal head-to-body relationship we can roughly gauge the relative sizes of other parts of the body. A male torso is three head-lengths long, the thirds being approximately marked by the chin, nipples, waist and crotch; the hips are half-way up the body. The upper and lower legs are each two head-lengths long and the shoulders are just over two head-lengths wide. A woman's proportions are slightly different. Her torso is a little longer than a man's but her legs are slightly shorter. Her waist-to-shoulder measurement is shorter but her waist-to-thigh measurement is slightly longer.

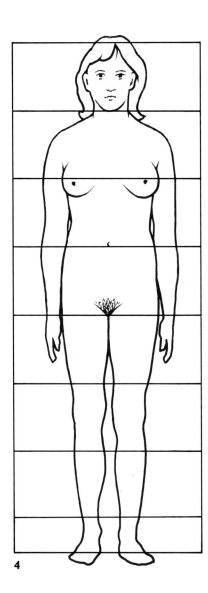

4

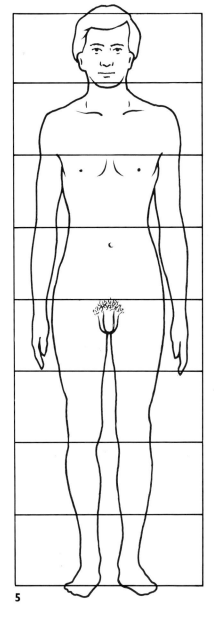

5

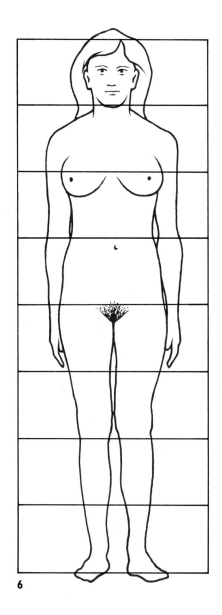

6

Just as the relative vertical proportions of mature men and women differ, so do their horizontal proportions, giving them their distinctive shapes.

Male and female body shapes

The widest part of the average man is across his shoulders – they are about two and a third head-lengths wide. The average woman, however, has shoulders only about two head-lengths wide; she is broadest across her hips. If you study and compare the sketches on the right and below, you can see the differences in shape. Note that the woman's waist (*below*) is far more evident than the man's (*right*).

These figures (*below* and *right*) were drawn in soft pencil on cartridge paper. They show quite clearly the difference between the shapes of a woman's head and torso, and those of a man

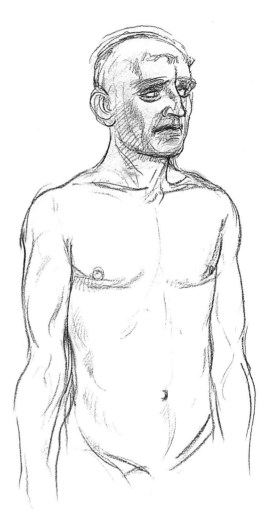

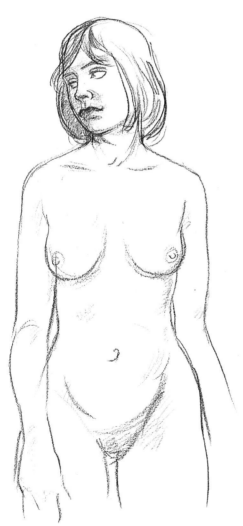

Using shapes in drawing

It's easy to reduce a complex posture to simple shapes that you can then elaborate into finished figures. To reveal underlying shapes and structures, try to develop 'X-ray vision' to see through the superficial clutter of clothing.

Always look at the space around a figure and surrounding objects or other people. A line made by a limb or body forms a shape with the surface it touches. You will find that most of the shapes you see will be triangles, rectangles and spheres. Underlying triangular forms are often found in reclining figures, such as in the one opposite, because of the joints in limbs. You must also remember that parts of a figure that are close to you may appear larger than those further away.

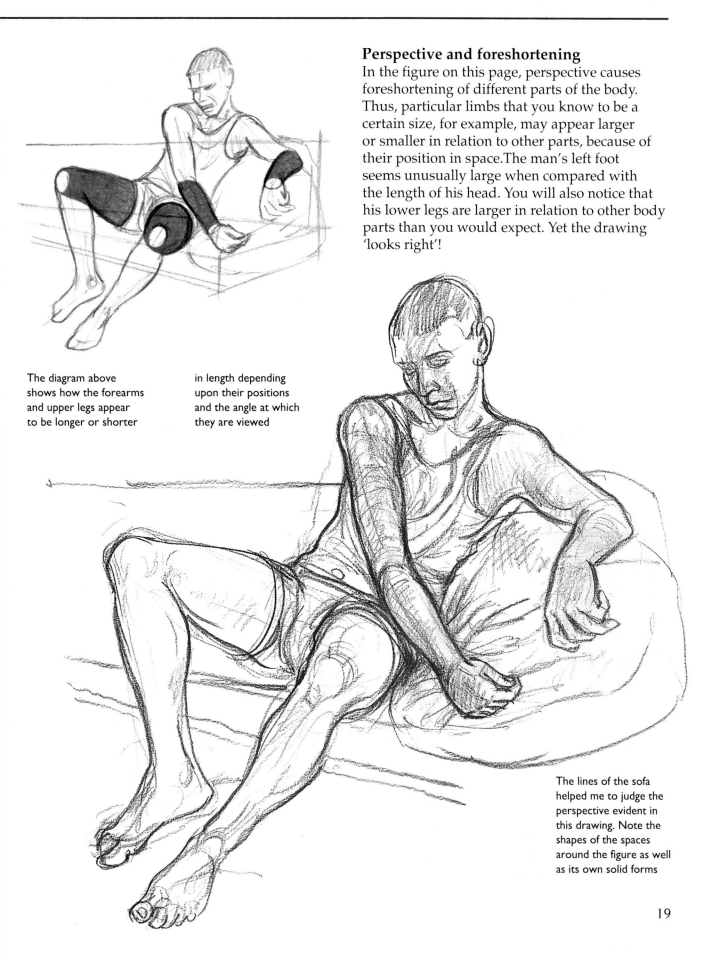

Perspective and foreshortening

In the figure on this page, perspective causes foreshortening of different parts of the body. Thus, particular limbs that you know to be a certain size, for example, may appear larger or smaller in relation to other parts, because of their position in space. The man's left foot seems unusually large when compared with the length of his head. You will also notice that his lower legs are larger in relation to other body parts than you would expect. Yet the drawing 'looks right'!

The diagram above shows how the forearms and upper legs appear to be longer or shorter in length depending upon their positions and the angle at which they are viewed

The lines of the sofa helped me to judge the perspective evident in this drawing. Note the shapes of the spaces around the figure as well as its own solid forms

Light and Shade

To portray a figure's receding and protruding forms you need to explore the effect of light on its surface. Skilful use of light and dark tones can emphasize shape and depth, and is especially important in drawings where features, such as the nose, are difficult to show without tone.

Using tone in shapes

Use the block method to help your shadow studies. To simplify faces or figures, draw them as a series of flat planes, as though your subject were made of cardboard.

The difference in tone on this cube (*right*) is shown very clearly. Only three tones are used. This method of shadow study helped me to judge more easily the play of light on the head (*below*) and the nude (*far right*)

A fully modelled figure drawing is quite complex, so limit yourself at first to white, black and a mid grey. With practice, you'll soon be able to handle a wider tonal range.

Here, depicting the head and nude as a series of planes makes it easier to see which areas are darkest and which are lightest

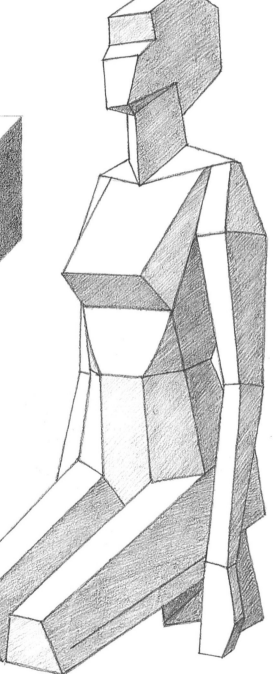

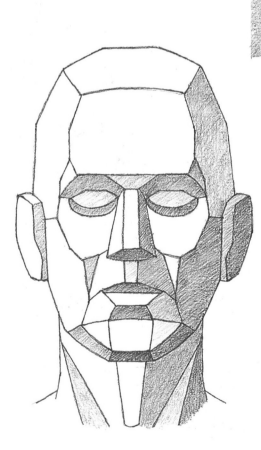

Use the darkest tones for parts that lie in cast shadow, lighter tones for planes facing away from the light and leave areas affected by direct light white. Bright light from a single source creates strong shadow and highlights. A wide range of grey tones lies between these extremes, but use only as many tones as you feel necessary. If light falls on a subject from more than one direction it tends to reduce contrast, resulting in lighter areas of shadow.

Try sketching someone lit from a variety of sources – use an adjustable desk lamp – to see how they change your subject's appearance.

The light shining on the sphere (*right*) appears to come from the top left because its left side is brighter than its right. You can see a similar effect on the head (*below*) and on the nude (*far right*)

The contrast between dark and light emphasizes the curves and angles of the man's face (*bottom*), giving it shape and depth.

A similar effect can be seen in the nude figure below. Note how cast shadows darken those areas already in shadow

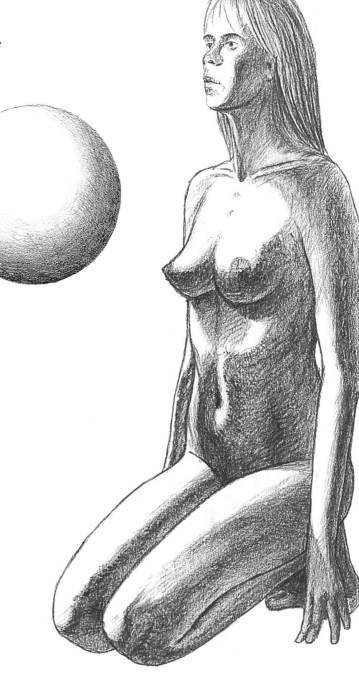

Structure and Form

Relationships between parts of the body
Anatomical knowledge is not essential to draw figures, but you should understand how the main body parts – head and neck, torso and limbs – articulate together. The neck, for example, is not a vertical tube joining the torso and head – it is angled forward.

Various ways of simplifying the human body, to facilitate the study of structure and form, are shown on these pages. It's more useful to see how jointed bones move against each other than to be able to draw their shapes. A matchstick figure can show how the main joints pivot in any posture.

The skeleton, tin-can and silhouette studies below helped me to understand the subject's posture and the relationships between different parts of the body

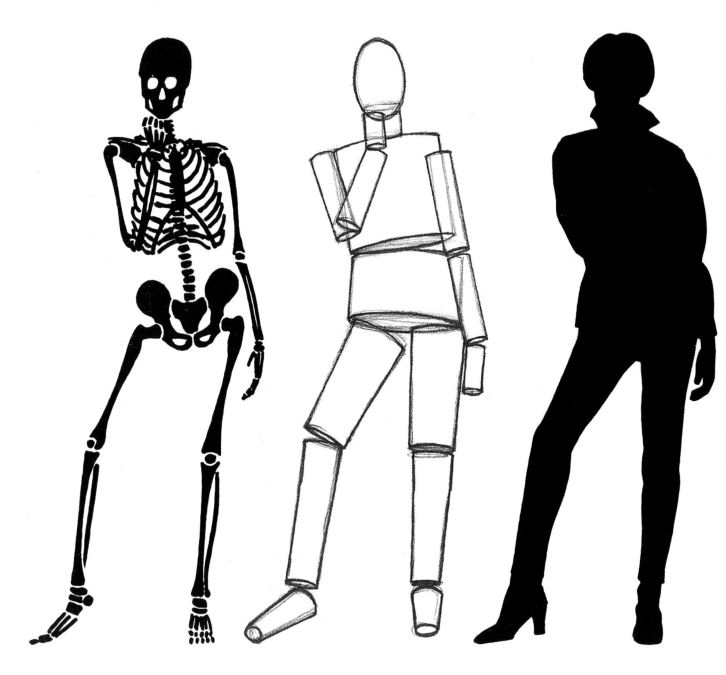

Even such a simple device will look 'wrong' if you don't observe the correct relationships between the different skeletal parts.

Skeletal study

A basic knowledge of the skeleton can help you portray realistic movement; its axis, the spine, limits the movement of the main forms joined to it. It is especially useful to be aware of bones that are apparent under stretched skin. Elbow, wrist, knee and ankle joints are always visible, as is the spine, which is very prominent just above the shoulder blades and where it meets the pelvis. Shoulder blades, collar bones and the upper pelvis rim are also distinctive. Remember that some poses accentuate bone structures – raising the arms, for example, causes the ribcage to become more prominent.

Tin-can study

A tin-can figure, using cylindrical shapes, is a good way to represent people simply. Its great advantage is that cylinders are easier to draw in perspective than complex forms such as thighs. You can modify these cylinders into truncated cones, which bear a closer resemblance to real limbs.

A basic tin-can figure is sufficiently convincing to form the basis for a fleshed-out, fully clothed form. To ease the task of fleshing out, an anatomical drawing from a book will help you to understand underlying shapes of muscles and how they stretch and contract.

Silhouette study

The solid form of a silhouette ignores the distracting detail of clothes and surface textures, and serves to remind you of the general proportions of the body. As well as looking at the shape of the body, look at the shapes formed between different parts of, and around, the body to help you get your proportions correct.

I practised drawing tin-can figures until I felt confident enough about shape and form to produce the finished drawing (*right*). It was drawn with a 2B pencil on cartridge paper

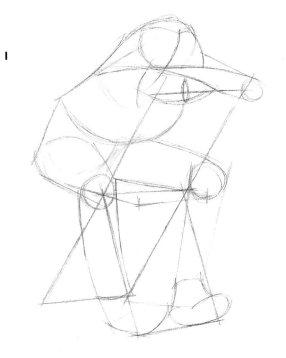

I

Drawing figures in stages

Drawing figures in positions other than simple standing poses tends to intimidate beginners. It helps to look for simple shapes. You will be able to see triangular shapes around joints; kneecaps and elbows can be seen as circles at the end of cylindrically shaped limbs. You can see, for instance, that triangles have been used as the basis on which the drawing opposite was built.

Concentrate on drawing different tin-can figure postures at first; don't begin to add detail until you feel happy with your basic figures. You'll need to master the tin-can figure so, if you're not sure about cylindrical perspective, practise perspective sketches of a tin can seen from every possible viewpoint, paying particular attention to foreshortening. Use pencil measuring to check angles and proportions.

2

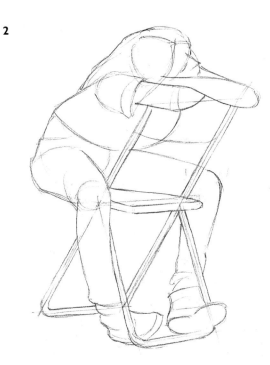

3

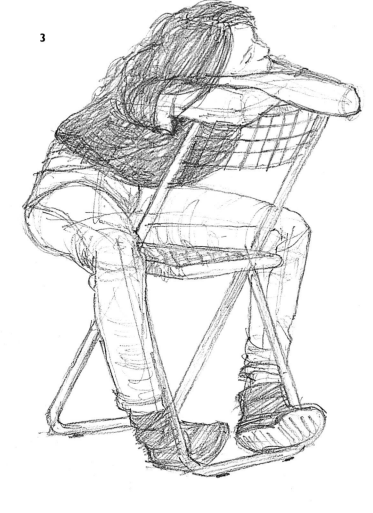

Here, you can see how I built up the drawing from a series of rhombuses (for the chair), triangles and circles (**I**). I then fleshed out the figure (**2**). Finally, detail and tone were added (**3**)

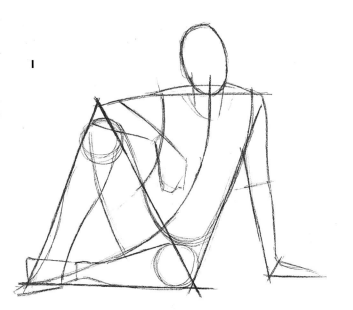

1

Begin by drawing the main lines of your subject's form; that is, a matchstick figure encompassed by any basic shapes that you can see. Look carefully at the relationships between the shapes and lines of the subject's body, keeping in mind proportions and perspective. Then include the cylindrical tin-can forms to show the beginnings of a fully fleshed-out figure.

When you've established the basic shapes, start to refine the figure's outline. Work on it until you feel that it reflects posture correctly, conveys the perspective of any foreshortened forms and shows accurately how limbs bend. Then you can begin to add major details, such as the hairline, the fingers and toes, and facial features.

Finally, round off the tin cans to produce more realistic fleshed-out forms. Look closely to see how muscles contract or stretch and if skin is folded. Remember that the shape of soft tissue on an arm, for example, changes shape when it comes into contact with a hard surface. Then add tone.

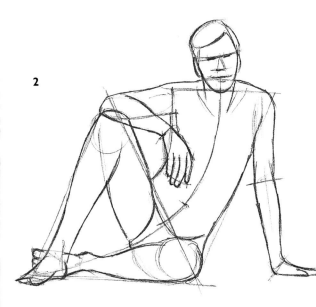

2

3

I started this picture with a series of triangles (1). The basic tin-can forms were then rounded and I began to add detail (2). The finished drawing (3) was done on cartridge paper in HB pencil

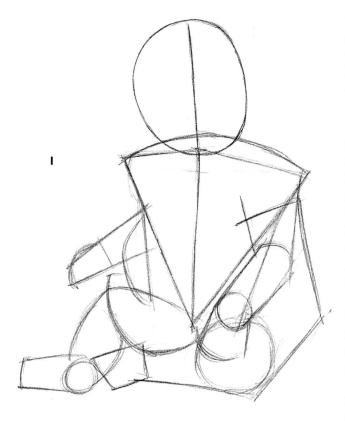

I

Babies

Sex, height, weight and age are variables that you'll learn to identify in adults. But babies differ dramatically from adults and children in terms of physical appearance.

Although the proportions are different, drawing a baby follows much the same stages as for an adult. Much of the skeleton is hidden by fat, but limbs will still look 'wrong' if your basic structure is incorrect. Develop tin-can forms into thin barrel shapes to reflect the shape of real limbs. A baby's feet and hands are large compared to the limbs. The cranium is much larger in relation to the facial area than in an adult but the features are much less prominent.

Babies are unable to keep still for any length of time unless they are asleep. Develop the fluid speed you need to draw them by first sketching adults or older children.

First, I identified the basic shapes that gave the subject form – circles, triangles, and so on (**1**).

Then I rounded off the shapes (**2**). Next, I began to add major details, such as the smock's folds (**3**)

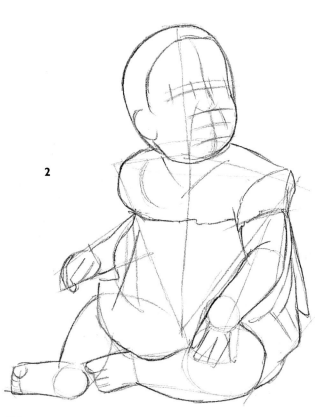

2

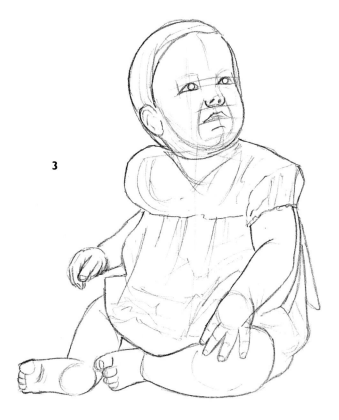

3

The finished drawing was done in H and 2B pencil on cartridge paper. I used shading to give the limbs roundness

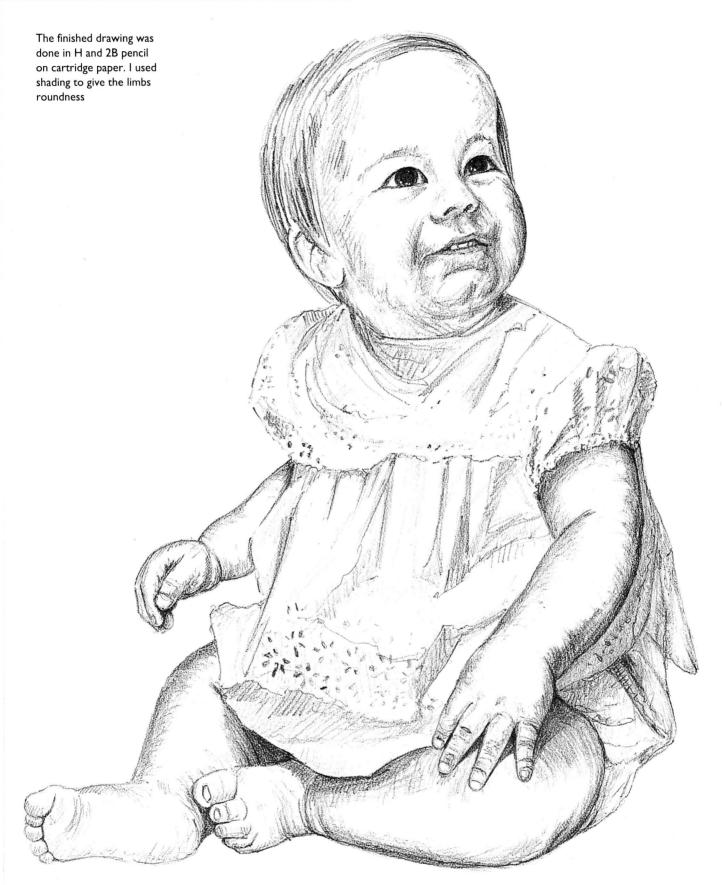

Heads and Facial Features

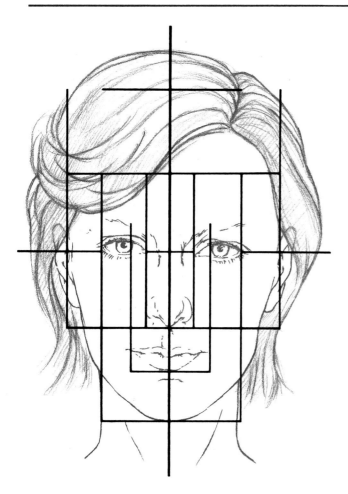

Positioning facial features

Whatever the size of the head or the shape of the face, the relative proportions and positions of the facial features are fairly constant from person to person. The relationships between these can be illustrated by dividing up a frontal view of the face using a grid (*left*). If you look at the central vertical axis, you will notice several things: the facial features are placed symmetrically; the eyes are halfway down; the eyebrows are level with the tops of the ears; the fleshy part of the nose is as wide as the distance between the inside corners of the eyes; and so on. Look at different faces and see how the features relate to one another.

The skull

The skull is integral to the shape of the face. The two studies below illustrate the relationship between the skull and the visible facial features.

I drew a series of lines over the portrait above to help me to understand the relationships between parts of the face and their relative dimensions

These two drawings (*below* and *right*) show the way in which the skull and bones of the neck are positioned and how they affect the visible features

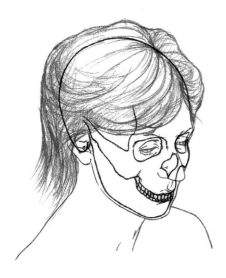

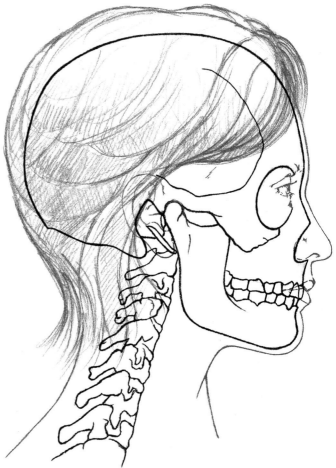

Perspective

To draw faces turned away from you at various angles means drawing facial features in perspective. Continuous curves in perspective are hard to draw, so it helps to make studies of the head using the block method. For a simple study, you could imagine the head as a box – the cheeks as two of the sides, and the underside of the chin, the face, the back and top of the head as the other four. For more complex studies, the head can be represented as a series of planes (*right* and *below*).

Parallel planes and the horizontal lines of the nose, eye or mouth levels are subject to the laws of perspective. For example, not only will the eye that is closest to you look larger but it will also appear to be slightly higher than the one furthest away. Certain features or the whole face will be dramatically foreshortened if drawn from certain angles (*below right*).

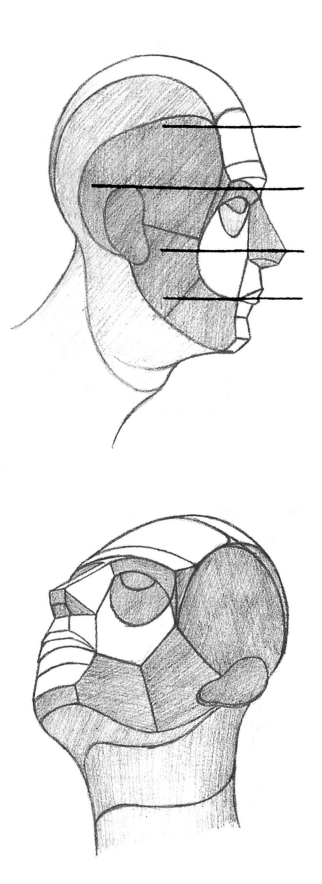

Here, a head has been represented as a series of planes. You can see from the profile (*right*) that the planes marked by the hairline, eyebrows and tops of the ears, nose and mouth are parallel. Even when seen from other angles (*below* and *below right*), these planes still do not converge

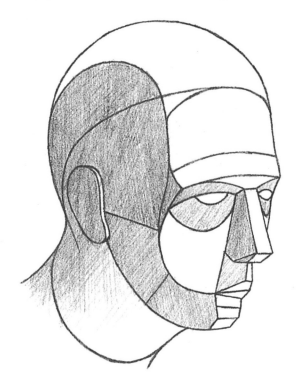

Drawing a realistic portrait of a person takes keen observation as well as an understanding of the theory involved. As with all drawing, practice makes perfect, and nobody will be a more patient model than yourself. Before you use the step-by-step stages given here to draw yourself, become familiar with your own face. Look at yourself in the mirror and feel the bumps, hollows and contours that make up your face. Your nose juts out below your eyelevel. Where the fleshy parts surrounding the nostrils meet the cheeks, there is a distinct dividing line. The other curves on the nose are gentler.

When you draw the eyes, remember that they are spheres held in skull sockets. They appear to be oval because they are partly obscured by the eyelids, which follow the eyeballs' curves. Use a bright light to throw facial forms into strong relief.

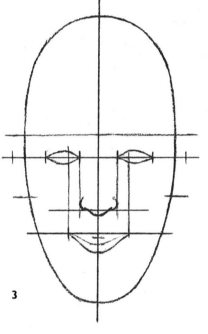

3

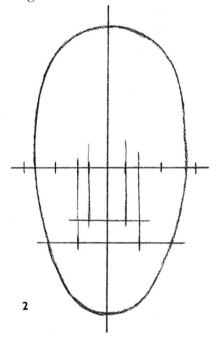

2

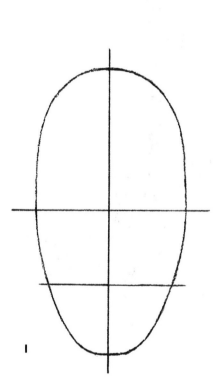

1

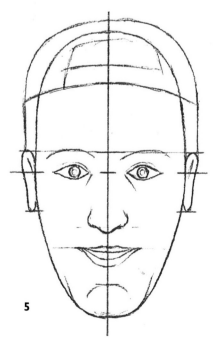

5

I divided a rough egg shape with a central vertical line and then with two horizontal lines – one at eyelevel and one to mark the position of the mouth (**1**). I placed the features with the aid of these axes (**2**): the eyes are one-fifth the width of the head; the bridge of the nose is, too, and it ends a third of the way down between the eyes and the chin. I then drew the mouth (**3**), aligning its corners with the inside edges of the irises. Next, I aligned the eyebrows with the tops of the ears (**4**)

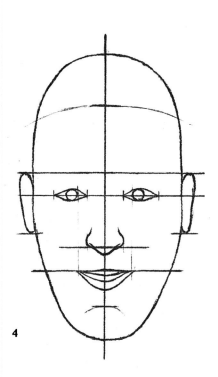

4

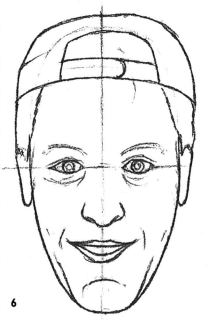

6

7

The last major element to be added was the cap which hid the hairline; then the finer detail of lines and wrinkles was put in (**5** and **6**). If you feel unsure about using tones to give depth to the finished drawing (**7**), do a few tonal studies first

Be guided by general principles, but don't let them dominate your portrait. Draw what you see, not what theory dictates; after all, no face is the same – each has its own individuality. Remember, though, that everyone's features are (generally) arranged symmetrically.

Portraying Expressions

Our feelings are laid bare in our expressions, and convincing facial expression in a portrait will convey more than any amount of meticulous rendering of hair or skin tones. When you make portraits of friends, try to depict typical expressions that sum up their personalities.

Mood is often fleeting and subtle, making it hard to capture. Compare the two women's heads on these pages; neither exhibits extreme emotion and both could convey quiet reflection, yet the smaller portrait suggests calm while the larger depicts a more sombre feeling.

We see little of the eye in this sensitive pastel (*opposite*), yet a slight downturn of the mouth suggests sadness. Subdued lighting adds to the mood

This pencil drawing shows a woman whose eyes and mouth convey a 'neutral' expression, suggesting an enigmatic feel (*above*)

In this smiling face (*right*), certain lines and wrinkles are very prominent. The mouth is wider and the eyes narrower than in the portrait above

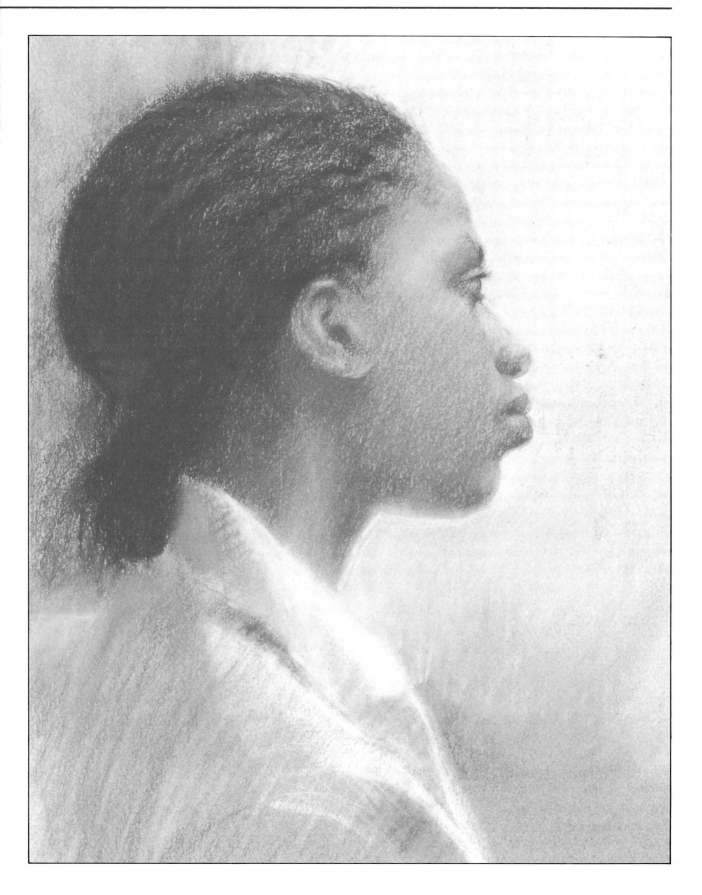

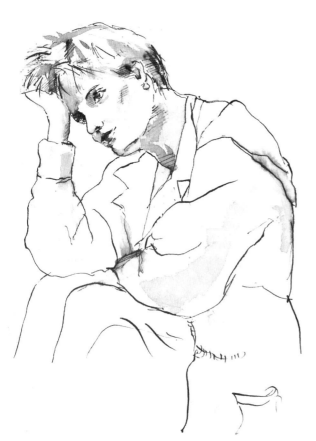

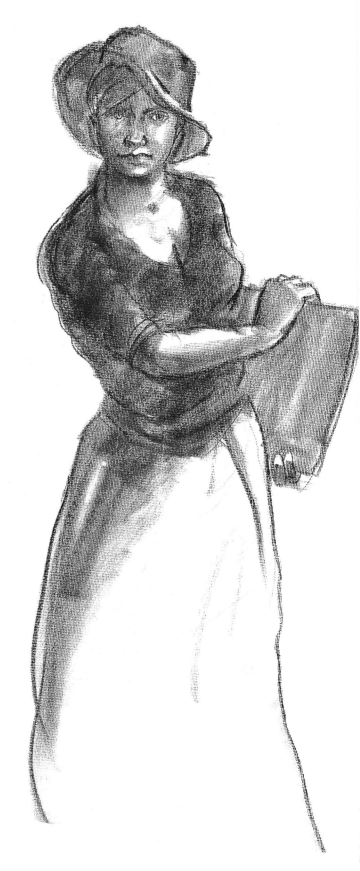

The girl above, in a pensive mood, was drawn in pen and ink on watercolour paper. A little tone was added with a watercolour wash

This young woman (*right*) was drawn in charcoal on textured paper. The cool stare and the way she is holding the object in her hands denote defiance

Just as you examined your own face to learn about facial features, so you can observe different expressions in front of a mirror.

When certain facial expressions are assumed, study how the movement and changing shape of features, such as the eyes and mouth, affect the cheeks, lines around the nose, and so on.

You will find that you will need to make only subtle changes to features to convey many expressions. For example, only a slight alteration to the corners of the mouth of a person who looks indifferent will produce an expression of mild amusement.

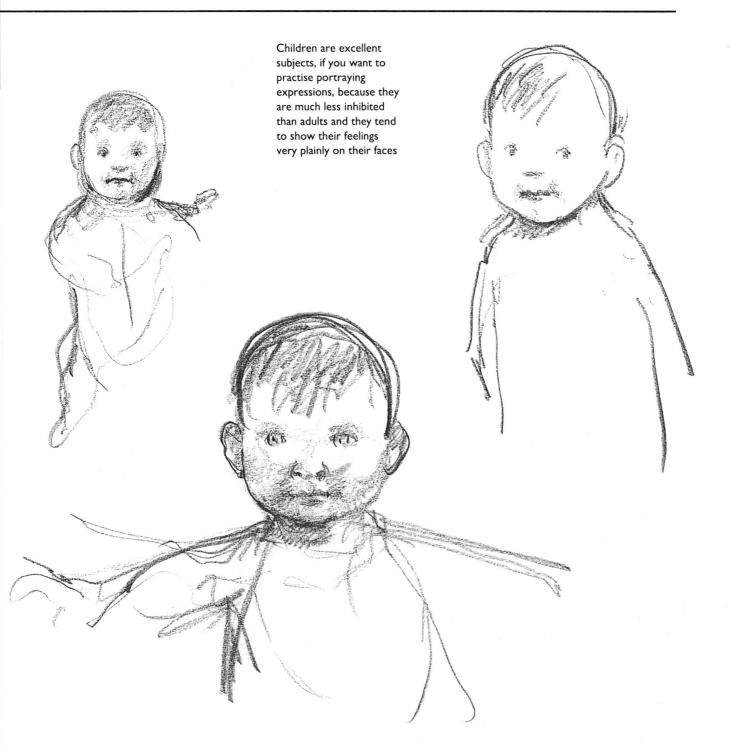

Children are excellent subjects, if you want to practise portraying expressions, because they are much less inhibited than adults and they tend to show their feelings very plainly on their faces

Posture

Posture helps to reinforce an expression. In the drawing of a seated woman opposite, for example, her slouched posture, with her head resting on her hand, seems to confirm the facial expression of tired pensiveness.

Children's expressions

To portray children, you won't be able to make quite so much use of facial lines to convey expression. The ways they show emotion are not as subtle as adults', so changes in the shape of the face, eyes and lips may be readily exploited.

35

Hands

Hands can reinforce the emotion or mood of a piece of work. For example, a clenched fist might portray anger or tension; hands with the fingers spread apart, tips touching, would suggest a contemplative mood.

Studying hands

Although drawing them requires care, the hands you draw need not be an exact likeness of the subject's. Study them to gain an understanding of the proportions. Note the shapes and differing lengths of the fingers. Remember that fingers have three joints and thumbs have two.

Drawing hands

It's best to practise by studying your own hands. First, spread out your hand on a sheet of paper and draw an outline round it to show different finger lengths. Fill in the outline as a silhouette to reveal its overall form. Next, rest your hand on a table to do a freehand sketch of it – note where the joints (the widest parts of the fingers) are and how each finger points in a slightly different direction.

Examine and depict the back of your hand and then the palm. With both, sketch the outline first then add the detail of ridges and lines. Draw a side view of your hand, showing the overlapping forms and the thickest parts. Use what you learn from these simple exercises as aids to drawing hands in different positions.

Here, I've drawn the back of my outstretched left hand and a side view of it. I repeated the exercise using the hands of willing friends

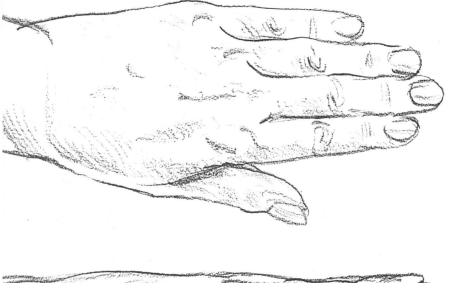

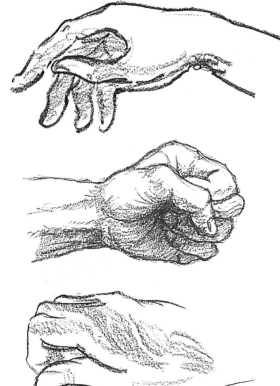

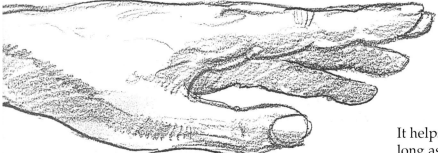

It helps to remember that the hand is about as long as the distance from your hairline to your chin. The broadest part of it, across the knuckles, is as wide as your middle finger is long.

To help me to understand the shape and form of the hand a little better, I made a series of studies of a variety of poses

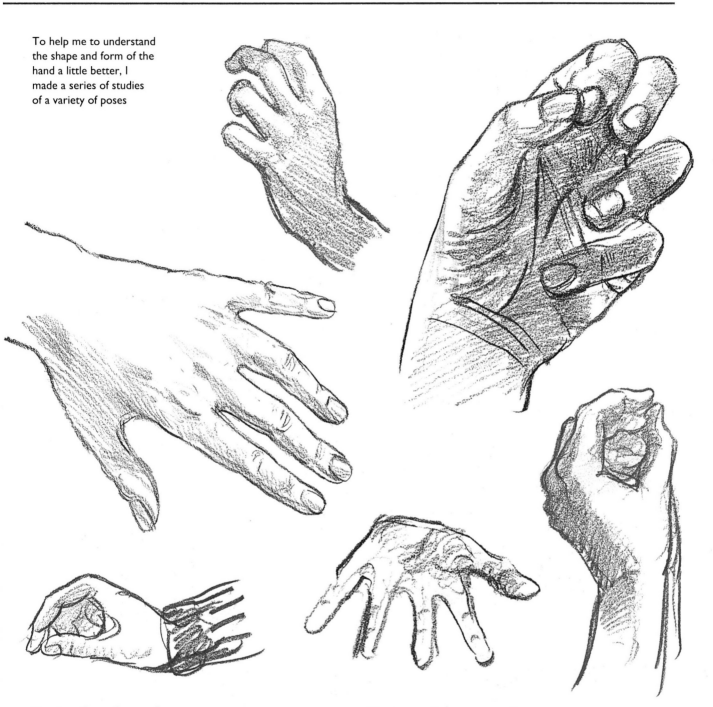

Seeing hands as shapes

Try to see hands as overall forms – a clenched fist as a sphere or an open hand as a shallow dish; adding fingers one by one rarely gives realistic results. Just as a tin-can figure simplifies the body, so you can draw the fingers of a hand as an assembly of tubes, each with a slightly different alignment and independent articulation at its joints.

Poses and movement

Practise drawing your hand in various poses, sometimes holding implements, and from different viewpoints. Try to 'freeze' different stages of a movement, such as the action of a waving hand. Always remember that the thumb is attached to a large joint near the base of the hand. Look to see how forms overlap and obscure each other.

Feet

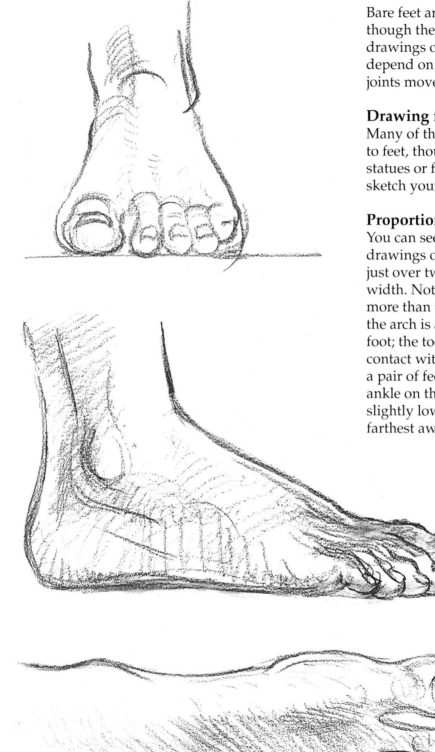

Bare feet are much less flexible than hands. Even though they are usually hidden, realistic drawings of people walking or running in shoes depend on an understanding of how the foot joints move.

Drawing feet
Many of the hints to help you draw hands apply to feet, though you'll need to use photographs, statues or friends as models, for it's harder to sketch your own feet than your hands!

Proportions
You can see the widest part of the foot in the drawings on this page; its maximum length is just over two and a half times its maximum width. Note that alignments of the toes vary more than those of the fingers. Remember that the arch is a slight hollow in the underside of the foot; the toe tips of a standing foot are all in contact with the ground. If you choose to depict a pair of feet from the side, don't forget that the ankle on the outside of the foot closest to you is slightly lower than the inside ankle of the foot farthest away.

With the toes at eye-level, the study at the top of the page shows severe foreshortening of the body of the foot and its toes

A side view of the foot reveals its depth at the instep, the length of the toes and the way they overlap (*above left*)

When viewed from above (*left*), the widest and narrowest parts of the foot can be seen

The feet below were
drawn in a variety of
poses so that I could refer
to them when drawing
moving figures

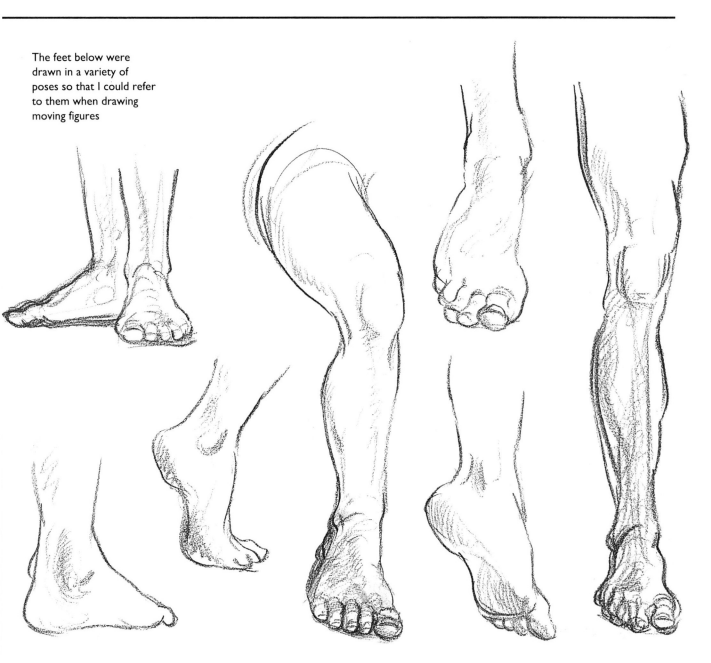

Seeing feet as shapes

As with a hand, look at a foot as a whole – a
blunt wedge, hinged at the ankle and where the
toes join the main form. The ankle is an ovoid
protruding from the lower leg.

Movement

Weight on a walking leg is first transmitted via
the heel; it shifts to the ball of the foot as the toes
begin to bend. Finally, just before the foot leaves
the ground, most of the weight is on the bent
toes, and the instep rises vertically above them.

When people walk or run, the feet function as a
pair, with the body weight shifting from one to
the other. Note how the muscles of the foot tense
and relax with the shift of body weight. Study
the times at which both feet touch the ground in
movement and look at how they are shaped.
Only one foot is ever in contact with the ground
when a person is running.

If you look down as you move, you will see that,
rather than pointing in the direction of
movement, your feet point outwards slightly.

Surface Texture

A variety of textures are encountered when drawing people – textures of hair, skin, clothes and so on, all of which come in a wide variety of textures themselves. For example, hair may be curly or straight and skin wrinkled or smooth. You need to be able to depict these accurately to lend realism to your work. Real textures are represented on paper as **invented texture**.

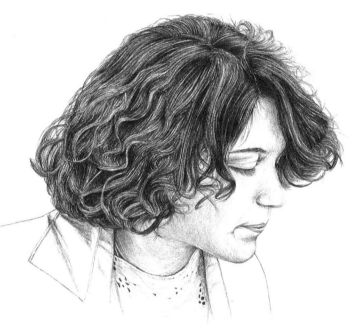

Notice how, in this B-pencil drawing (*left*), the young girl's coat and boots have a reflective quality which is absent from her softer clothing

I used 2B-pencil strokes of varying pressure to show the texture of this girl's hair (*above*). They contrast with the HB-pencil strokes of her face

Invented texture

You can describe various textures by using patterns of lines, and light and shade to emphasize wrinkles and contours. You can also exploit the qualities of your work materials (see pp. 4–11 and 12–13). For example, you can reveal the surface quality of cartridge paper by rubbing a soft pencil over its surface. Much of the texture in the drawing of the fisherman opposite has been represented in this way. And several different textures have been evoked by coupling this method with the judicious use of highlights and shadows.

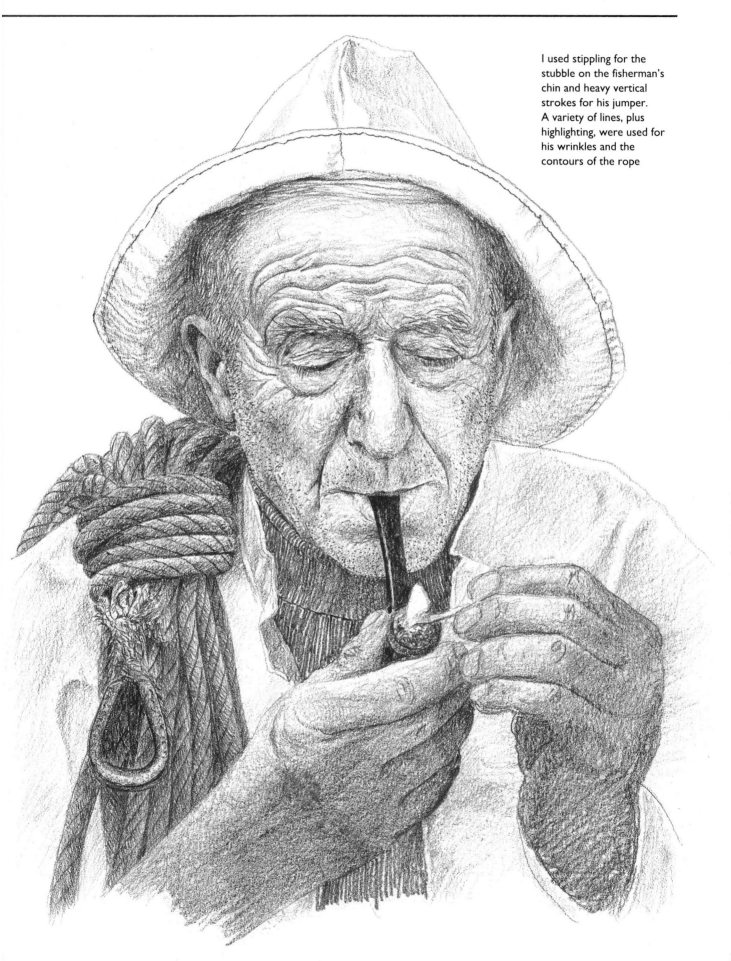

I used stippling for the stubble on the fisherman's chin and heavy vertical strokes for his jumper. A variety of lines, plus highlighting, were used for his wrinkles and the contours of the rope

Sketching

Good drawing flows from keen observation and a confident stroke. Constant sketching is the best way to acquire these skills. Start with people who will stay still long enough to be sketched – pubs, beaches, trains or cafés will provide plenty of subjects. Sketching people in various positions develops your visual understanding of the human figure at rest or in motion.

Don't worry about unfinished sketches and don't get bogged down with detail, especially if people are moving – concentrate on basic forms and try to capture the flow of movement.

Never throw away sketchbooks – they record your progress. You could develop your sketches into more formal drawings, too, at a future date.

The quick sketch of the woman opposite was drawn in soft pencil on rough paper

I rapidly sketched these people walking on a winter's day (*above*) with a conté crayon

Whilst we were sitting and chatting, I captured my friend with quick B-pencil strokes

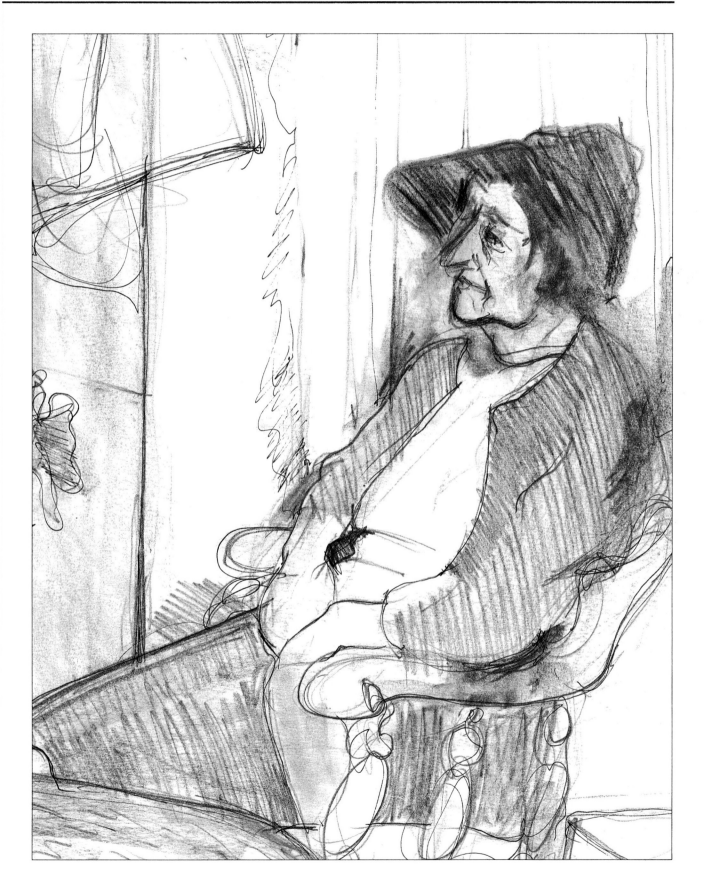

I visited a kindergarten and made a series of one- and two-minute sketches of the children playing

If you draw moving figures or brief poses, you must work rapidly, concentrating solely on the main forms of the body. You can add detail later. Earlier sketchbook observations or theory can help you to complete any unfinished forms. As well as developing confidence in your sketching abilities, you'll have to train the eye to overlook subjects other than the people you want to sketch. The best way to acquire such skills is by making timed sketches of identical stationary figures, starting with a one-minute sketch and going on to two-, five- and twenty-minute sketches.

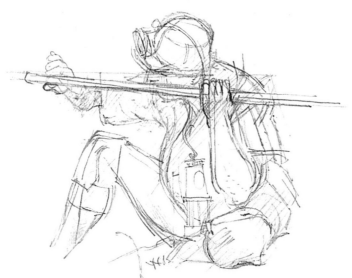

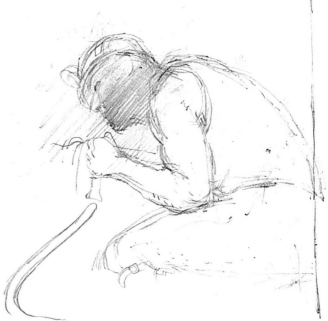

The sketches of the miners (*above* and *right*) were both done in under five minutes. I managed to capture more form and movement here than in the sketch on the opposite page

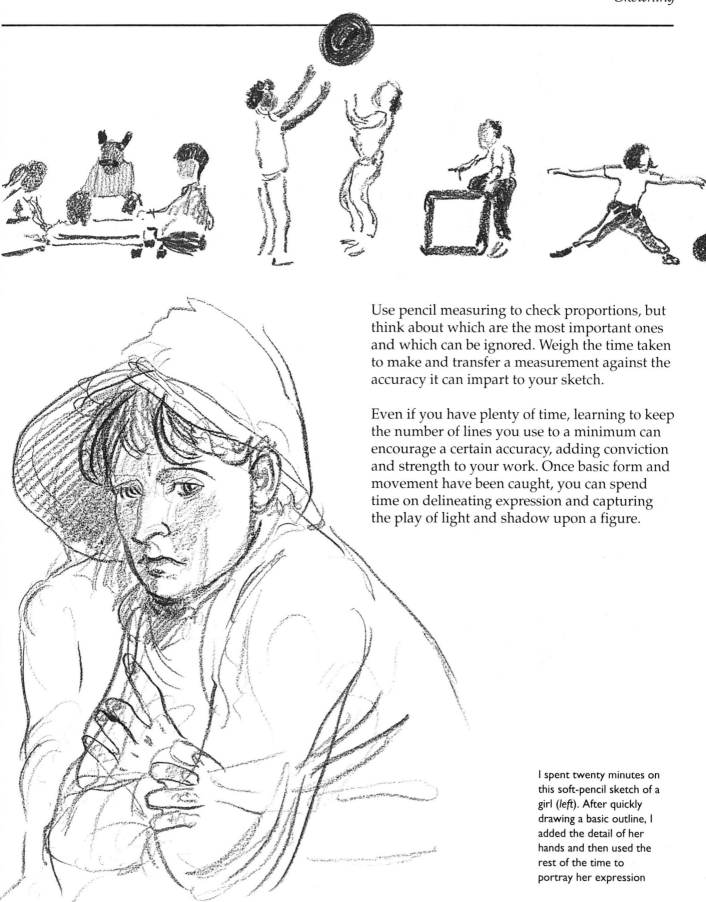

Use pencil measuring to check proportions, but think about which are the most important ones and which can be ignored. Weigh the time taken to make and transfer a measurement against the accuracy it can impart to your sketch.

Even if you have plenty of time, learning to keep the number of lines you use to a minimum can encourage a certain accuracy, adding conviction and strength to your work. Once basic form and movement have been caught, you can spend time on delineating expression and capturing the play of light and shadow upon a figure.

I spent twenty minutes on this soft-pencil sketch of a girl (*left*). After quickly drawing a basic outline, I added the detail of her hands and then used the rest of the time to portray her expression

Body Language

An intimate exchange of gossip is simply sketched in ink on cartridge paper (*right*). The angle of the profiled man's head conveys rapt attention as he leans close to listen to his friend, suggesting a whispered confidence

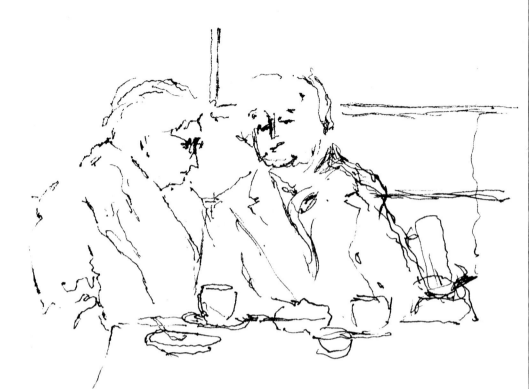

Oblivious to everything, this man (*below*) focuses all his attention on his newspaper. I sketched him in a local café, using pen and ink on cartridge paper

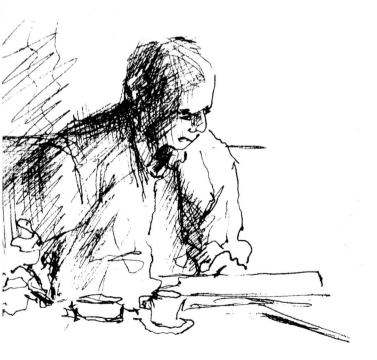

Body language and mood

Body language may be used to convey mood in a drawing. It can, for example, evoke weather: we shiver in the cold, even stooping slightly to conserve body heat. We strain for balance in strong winds, often leaning into a gale, while in extreme heat we show signs of lethargy.

Watch how certain moods affect people – anxiety and worry tend to produce rigid, tense postures, but relaxation can result in lazy, slumped forms.

Groups of people

Some body language is seen only within a group of people, when it reveals attitudes and status. Compare the postures of strong personalities, such as teachers or popular figures at parties, with the more deferential poses of those around them – look for aggressive stances in a challenge for leadership. Friendship promotes relaxed, open stances, and lovers may cling to each other. Children are interesting, for lack of inhibition tends to result in exaggerated postures. Elderly people are often more reserved, which (coupled with slower movement) creates a different kind of body language.

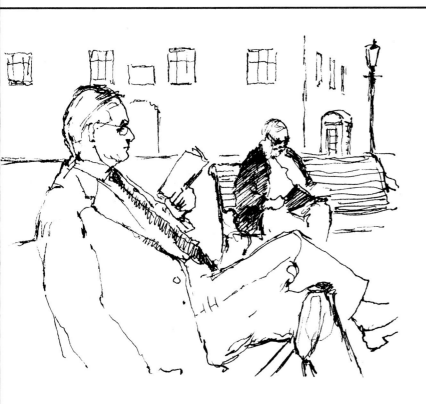

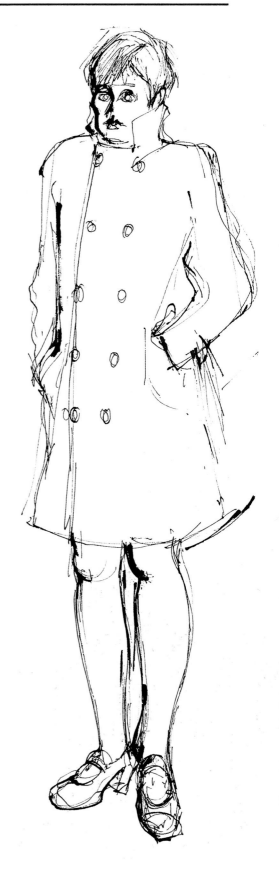

These two pen and ink sketches (*above* and *below*) provide good examples of how legs and arms are positioned when people relax on seats

Hunching her shoulders and keeping her arms close to her side, this chilly-looking girl was drawn with a dip pen on smooth paper (*right*)

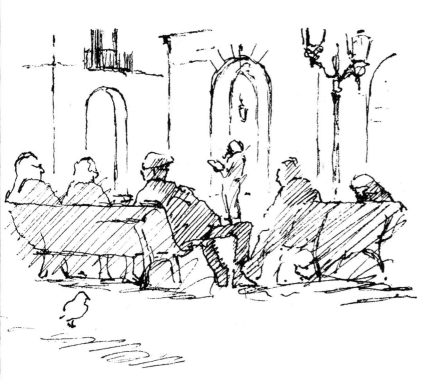

Framing and Composition

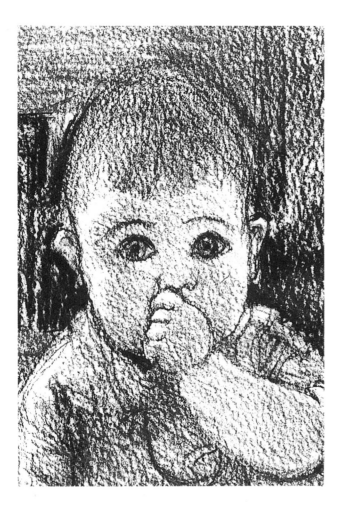

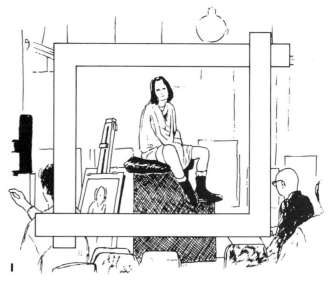

1

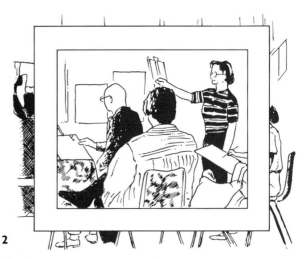

2

To achieve the composition above, I held a cardboard frame up to my subject, a toddler, to isolate the head and upper body

A composition does not necessarily have to reflect exactly what you see. You may want to arrange and place the various elements differently on your paper, or you may choose to focus on just one person in a group. You could focus on a part of your subject. For example, you might depict just the head, making the eyes the focal point, as in the drawing of the toddler's head above.

Relationships between separate elements are harmonized, in good compositions, to focus attention on the main subject. Decide at the beginning what your composition's focal point will be.

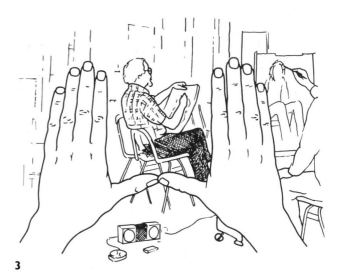

3

Framing

A group of people or a person may look complex. Framing a subject will help you to isolate various parts of it which, in turn, will help you to decide on the emphasis you want. Methods of framing are shown opposite.

You can make a frame from two pieces of L-shaped card (**1**), held up at right angles to make square or rectangular frames of varying sizes. A card frame that has dimensions similar to your paper is also useful (**2**). Alternatively, form one with your hands (**3**). Hold them upright, palms facing away from you, with the thumbs jutting out at right angles and touching.

Various subjects from the drawing below can be isolated by using the three framing techniques opposite

Practise simple compositions before you try complex ones. Make rough preliminary sketches, adding detail only when you've outlined the main forms. Use photographs to experiment with framing and composition techniques.

Surrounding detail

A nude on a sofa will look awkward 'floating' in space if you omit the sofa – you must add support. Some pictures need a context; the sketch of the art class below would seem incomplete without the room, which also helps to establish depth. Remember that backgrounds should complement, not distract – so don't use too much detail or texture.

The artists' postures and heads, and the perspective of the walls draw the eye to the focus of this art class – the model. Note how forms overlap, thereby holding the composition together

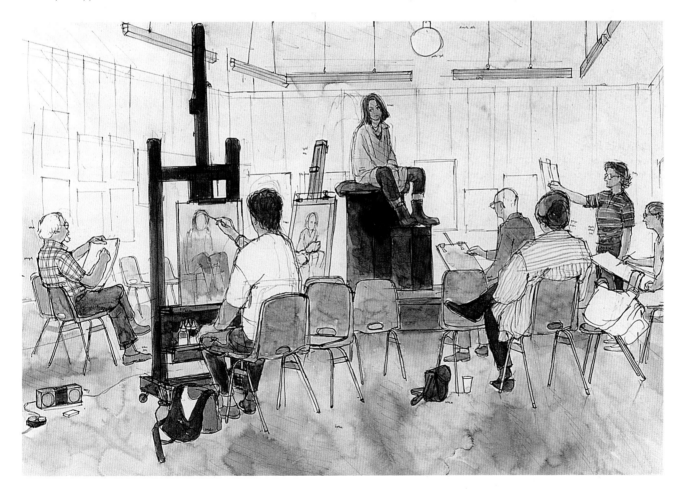

The Figure in Movement

Shifting weight distribution

The weight of a standing, motionless person is generally distributed equally over both feet to give maximum stability. When a person walks, the knees bend, and the head and torso lean forward – the weight of the body shifts from one foot to the other. The arms move, too, acting as stabilizers. To capture motion and to represent it, you need to study how parts of the body move – separately and together. Practise timed sketching to encourage your use of the rapid, fluid strokes needed to capture the figure in movement.

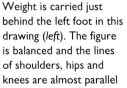

Weight is carried just behind the left foot in this drawing (*left*). The figure is balanced and the lines of shoulders, hips and knees are almost parallel

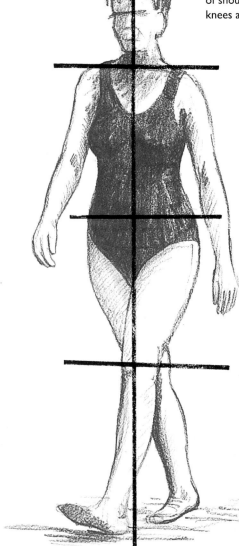

Begin your study by looking for the line of balance between the head and the feet. Also look for the lines of the shoulders, hips and knees, and the angles at which they slope (if they do). These lines represent the main weight displacement points of the figure – they reveal its balance and direction of momentum.

In the drawing below, the parallel lines show that weight is distributed evenly about the figure – the point of balance is directly below her head

The girl below is putting more weight onto her left foot than her right one; as a result, the lines of the shoulders, hips and knees are not parallel

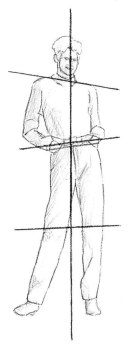

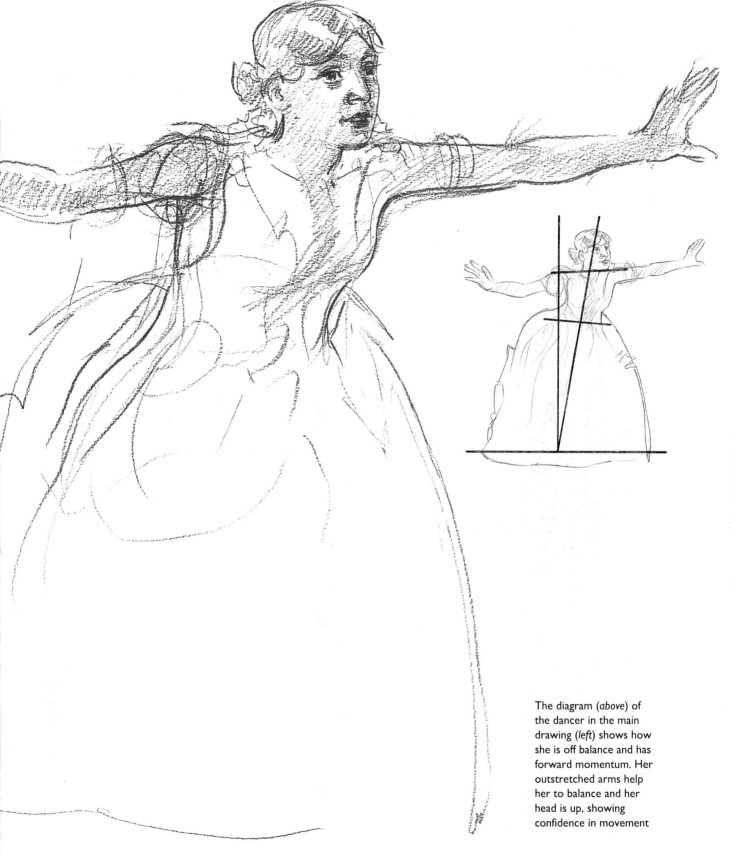

The diagram (*above*) of the dancer in the main drawing (*left*) shows how she is off balance and has forward momentum. Her outstretched arms help her to balance and her head is up, showing confidence in movement

Drawing leisure activities

Some leisure activities are easier to depict than others. People at a dinner dance, for example, may be simpler to draw than participants in an American football match because their movements are more repetitive and less vigorous. Whatever the type of motion, try to 'freeze' snapshots of it in your mind, then rapidly sketch the image. Make lots of rough studies and refer to them at a future date for your finished composition.

Note the direction in which the body is inclined, the angles of various joints, and the way the lines of the shoulders and hips slope. A firm understanding of body articulation is essential to represent motion.

This pencil study of an American football tussle (*right*) was created from previous sketches to give good form and structure to the figures

Energetic pen and ink and dry brush strokes bring the figures to life, and shadows and highlights add depth (*below right*)

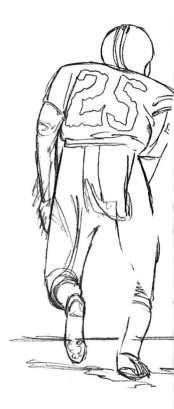

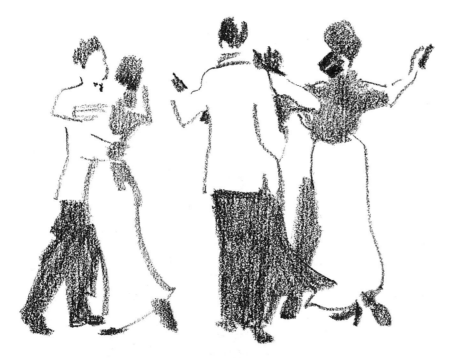

Clothing

Remember that loose clothing echoes movement. It billows out behind the body, as it moves, flowing in the direction of motion. If part of the body abruptly changes direction, the flow of cloth briefly lags behind, caught for an instant at odds with the figure's movement.

Note how movement of these dinner dancers (*above*) is portrayed in the flowing lines of the women's dresses

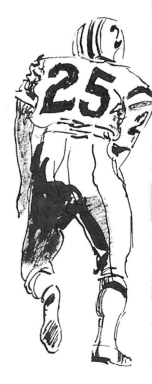

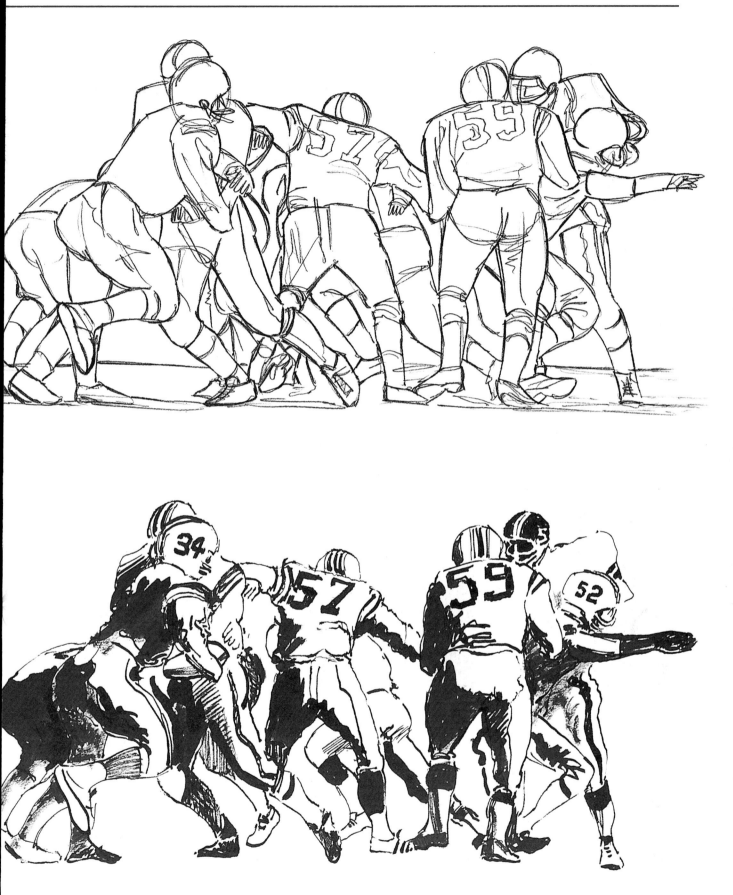

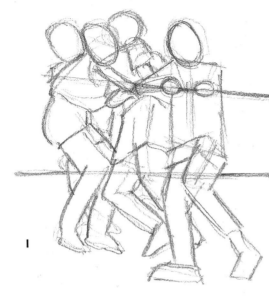

I I roughly sketched the figures in HB pencil, using the horizontal line for the ground and the rope as guidelines to work around

Pushing and pulling

A tug-of-war provides a superb subject for figure drawing, for the opposing teams freeze limbs and bodies in pivoting movements similar to those found in high-speed motion. You'll have time to capture the effort of exertion, but you'll still need to work quickly to exploit the situation fully.

Begin by drawing a horizontal line to represent the ground – this will be your central point of reference. Add the rope, showing the angle at which it is being pulled. Next, use quick, fluid strokes to sketch in the figures. Look for the angles of the lines showing the body parts' points of balance. Ignore detail but begin to add volume to the figures. Take care with joints – exertion makes them bend at extreme angles but not ones that would end in a hospital visit! Contrast the stiff, straight line of a braced leg with the bent form of its twin. Lastly, detail muscle groups. If there's time, try to capture a few faces expressing exertion.

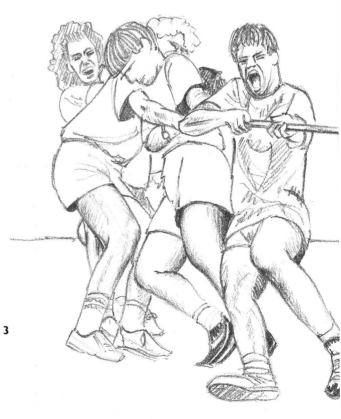

3

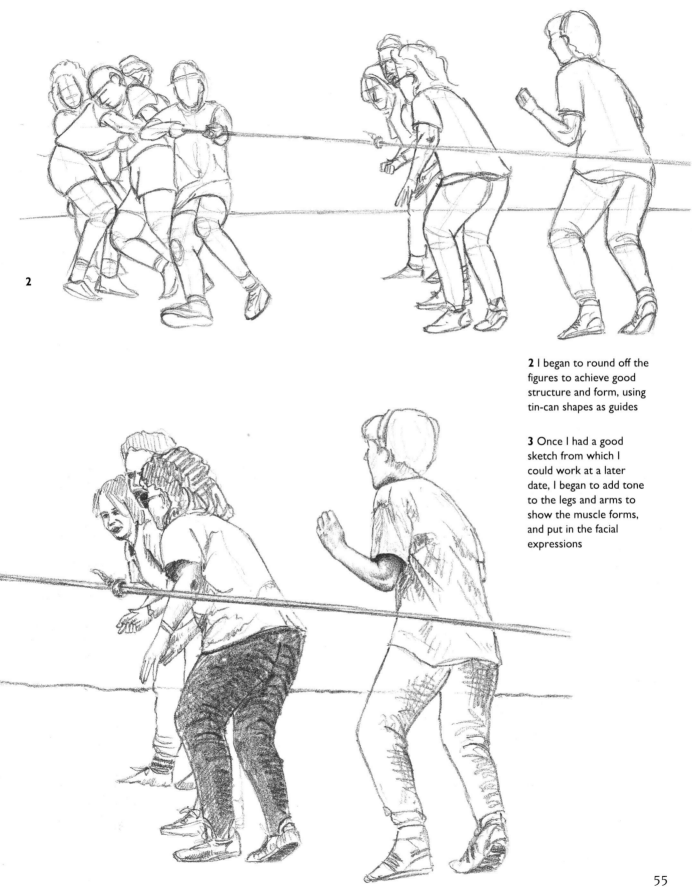

2

2 I began to round off the figures to achieve good structure and form, using tin-can shapes as guides

3 Once I had a good sketch from which I could work at a later date, I began to add tone to the legs and arms to show the muscle forms, and put in the facial expressions

People Indoors

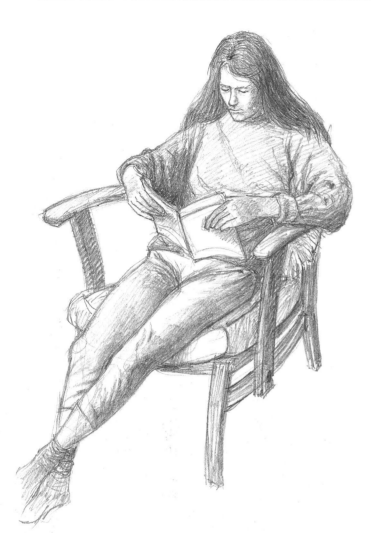

Many figure studies and most drawings, posed or candid, are done indoors. People tend to be stationary for much longer periods of time indoors than when they are outdoors, giving you more time to make detailed studies.

Constant light quality
Indoors, dramatic changes of light do not tend to occur as they do outdoors. This gives you more time to capture the mood of your subject.

Working at home
At home you can use whatever tools you like, including an easel. You can ask people to adopt formal or informal poses. You will produce relaxed and natural-looking drawings, such as the one on the left, if your subjects lounge comfortably on chairs or sofas.

Working inside public places
In public places, you will need to limit yourself to portable equipment, such as a sketchpad and pencil or capped pen, that you can slip into a pocket or small bag. If you decide to sketch people in places such as airports, stations, theatres, cafés and so on, you should ask their permission. They will probably cooperate and try to keep still for you.

Easily held poses tend to result in more natural drawings, such as the one above of a seated woman reading a book

The prone form below was portrayed with brush and ink. Note how I have drawn the pyjama stripes to suggest shape

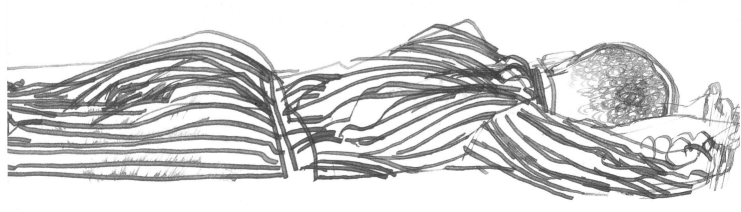

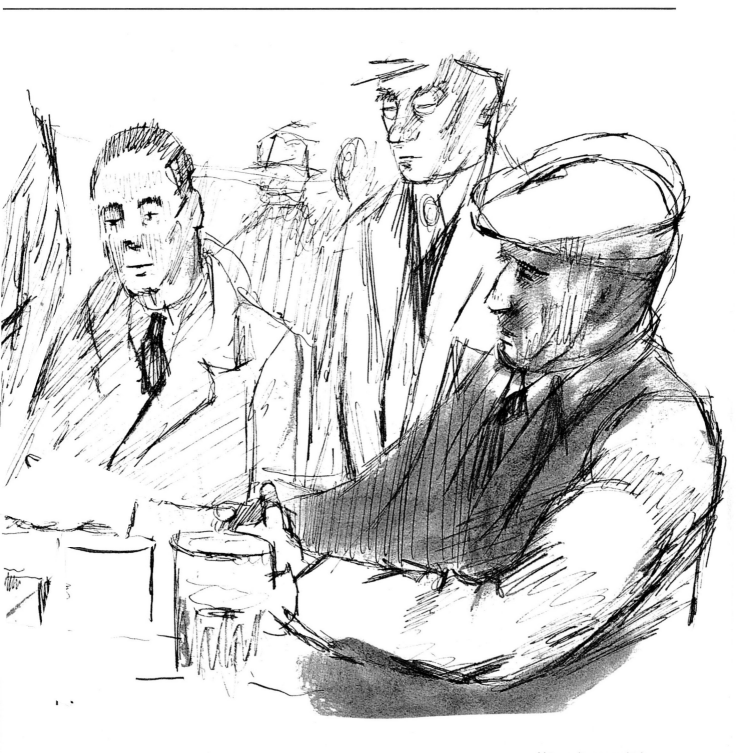

Using a dip pen and ink
on cartridge paper, I drew
these men at the bar in a
pub waiting for their
drinks. I sketched them
quickly because I knew
that they would soon
move away

People Outdoors

Don't take heavy equipment on outdoor trips.
It's often impractical to carry water and jars for
inks or paints, so use pencils or pens; sketchpads
make firm drawing surfaces. If you work in a
market place, for example, a lightweight folding
stool will help. Wherever you sit or stand, look
for a good viewpoint but don't get in the way of
other people. Candid drawings are best made
from unobtrusive positions.

Working quickly

Figurework tends to be more important than
portraits outdoors. Parks or sports grounds
provide opportunities to sit down and sketch
figures. In these places and elsewhere, people
are likely to be on the move, so you need to
work quickly – use the hints on the human body
in motion (pp. 50–55). Practise timed sketching
to capture fleeting figures who catch your eye.

A beach in summer was a
perfect place for me to
practise sketching people.
Those below were
captured in pen and ink
wash on cartridge paper

On a hot day, at the side
of a swimming pool, I
made quick, rough
drawings of sunbathers
with a brush and ink on
layout paper

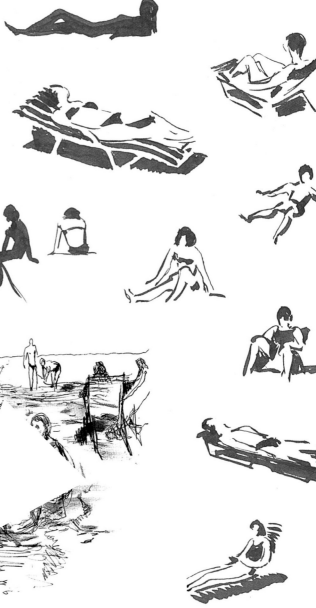

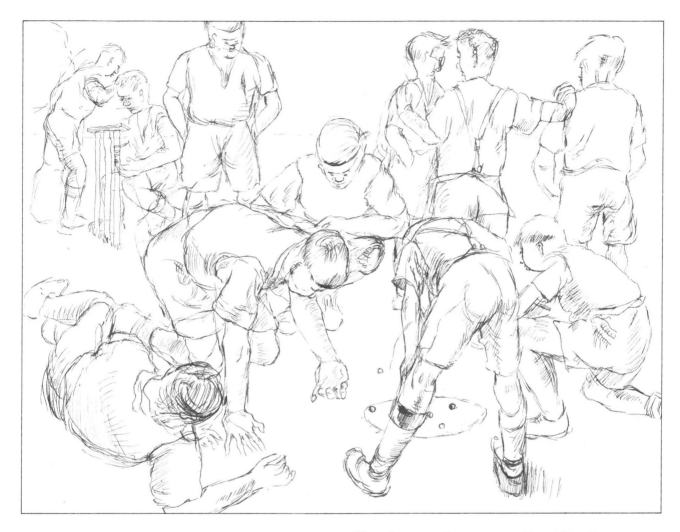

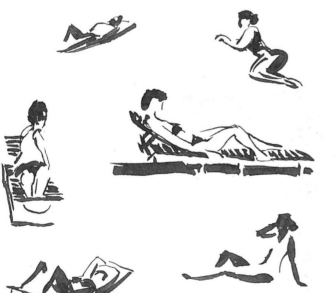

These figures are of the same boy in various poses (*above*). I sketched him quickly with a dip pen and ink on cartridge paper

Creating busy scenes

Ask willing friends to pose for you in your garden or on a beach or similar open space. The drawing of children's games above was actually drawn using one boy. He was prepared to pose in different positions to create the effect of a busy playground.

Using a camera

A camera will prove invaluable to snap scenes or figures you can't draw from life because of bad weather or lack of time. Try to take a sequence of shots so that you can choose the best when you get home. You can also combine a variety of elements from different photographs.

Working from Photographs

Working from photographs is an excellent way to increase your drawing confidence. Photographs reveal how body parts relate to each other when seen on a flat surface, and so will help you to understand these relationships.

Slavish copying of a photograph is not a good idea – it is wiser to exercise your creative skills. You can adapt the **contrast**, for example, by expressing a photograph's wide tonal range purely in black and white. You can also lighten or darken areas to enhance parts of it, or you can change the position of the light source.

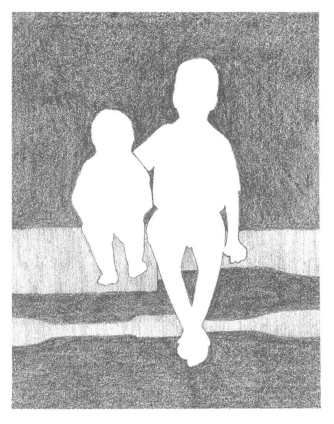

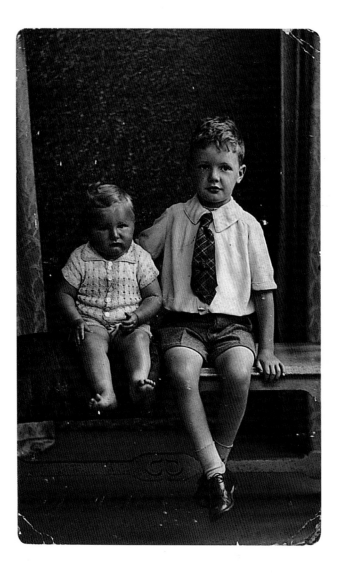

I referred to this old photograph (*left*), of a small boy and his baby brother sitting on a bench, for the finished drawing opposite

The diagram above shows how the spaces surrounding the subjects in the photograph relate both to them and the objects around them

Alternatively, you could **recompose** a photograph. If you decide to do this, you could add or delete people from a scene, change their facial expressions or even their hairstyles! When recomposing, it is a good idea to work from more than one photograph of the subject or subjects.

Before you start to draw, look at the shapes in the photograph very carefully. Don't look only at the shapes of the subjects themselves but look at the spaces around and between them, too. This will help you to ascertain the correct proportions in your drawing before you add features and tone. Don't ever finish a drawing until you are sure that the proportions and forms of the figure or figures are correct.

I used HB pencil on
textured paper for the
finished drawing. Note
how the different
textures – rough wood,
shiny shoes and soft
clothing – have been
represented

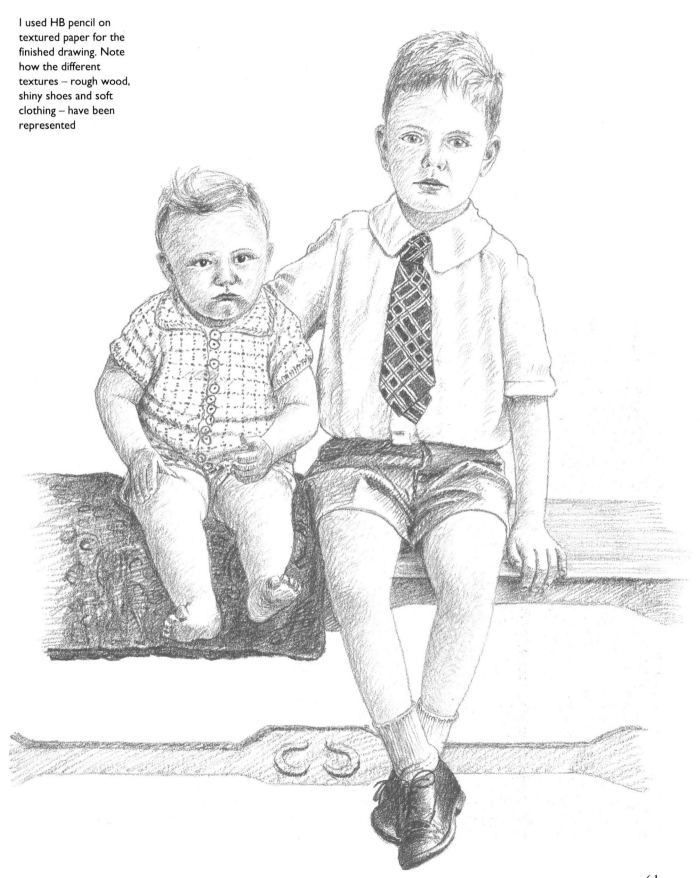

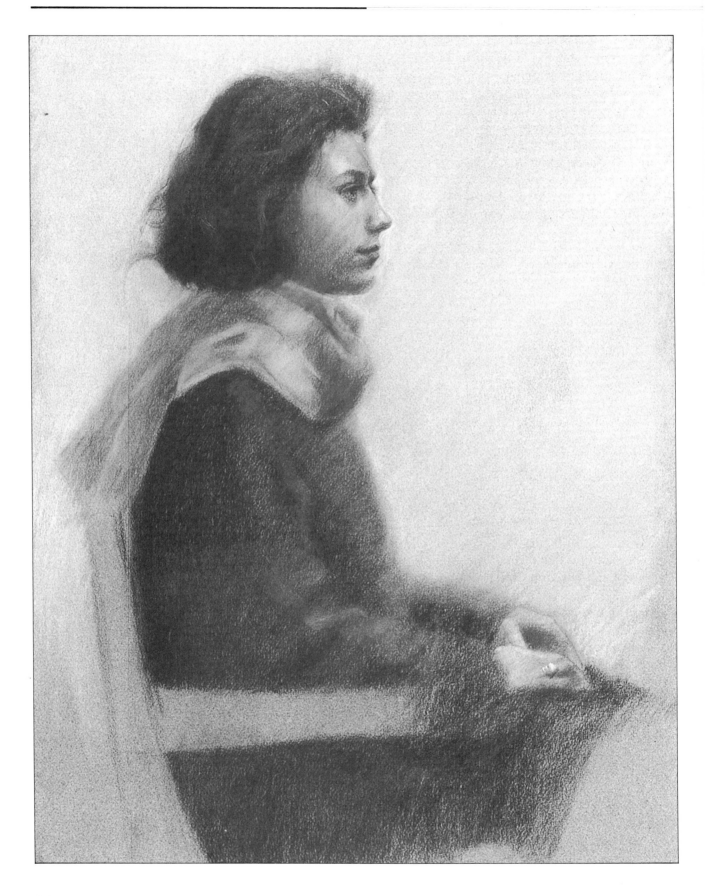

Fixing

Drawings and sketches are easily smudged, especially delicate pencil, pastel, charcoal or chalk work. Once you've finished a picture, spray it with aerosol fixative to prevent further smudging. Evenly cover your drawing, spraying from about 30–40 cm (12–16 in) away. Let the fixative dry before you handle the artwork. To be absolutely safe, you can add a second coat when the first one is dry. Don't spray incomplete drawings you want to finish at a later date.

A great deal of work lies behind this pastel portrait (*opposite*), so I protected it with a fixative

I applied fixative to the conté-crayon drawing on the right to keep it from being smudged

Storing

Store drawings flat and interleave them with clean tissue paper; don't roll them up. Some media fade, so protect your drawings from the light. A plan chest is ideal, but ordinary drawers will suffice. A large portfolio can be made quite easily from cardboard. They are also fairly cheap to buy.

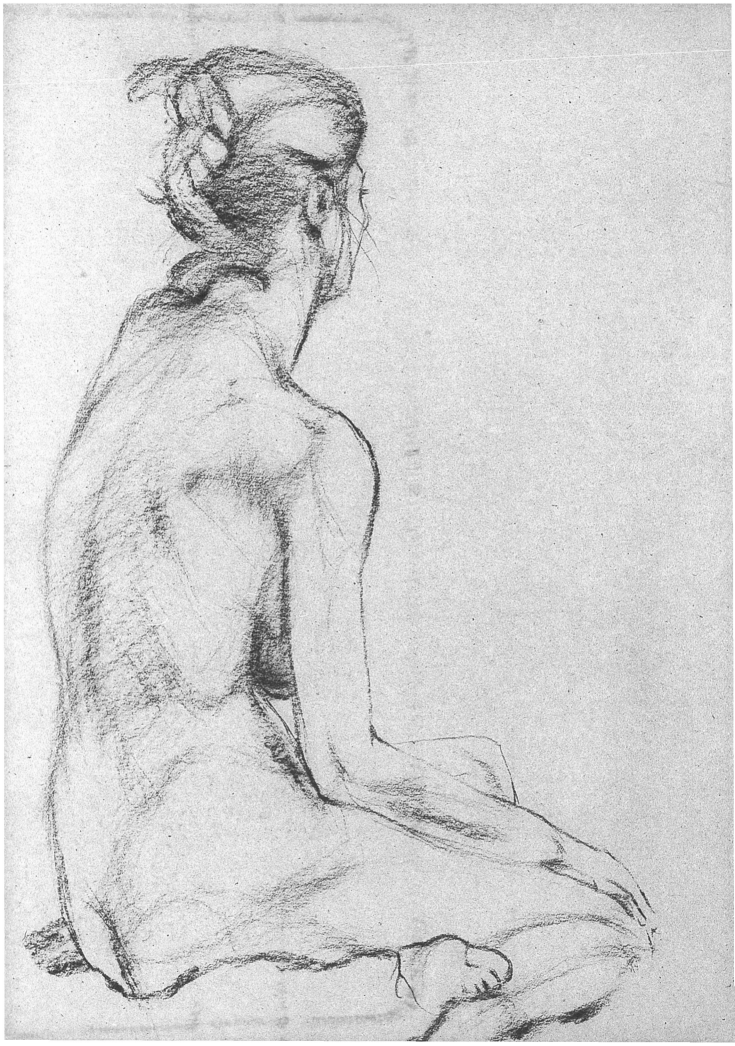